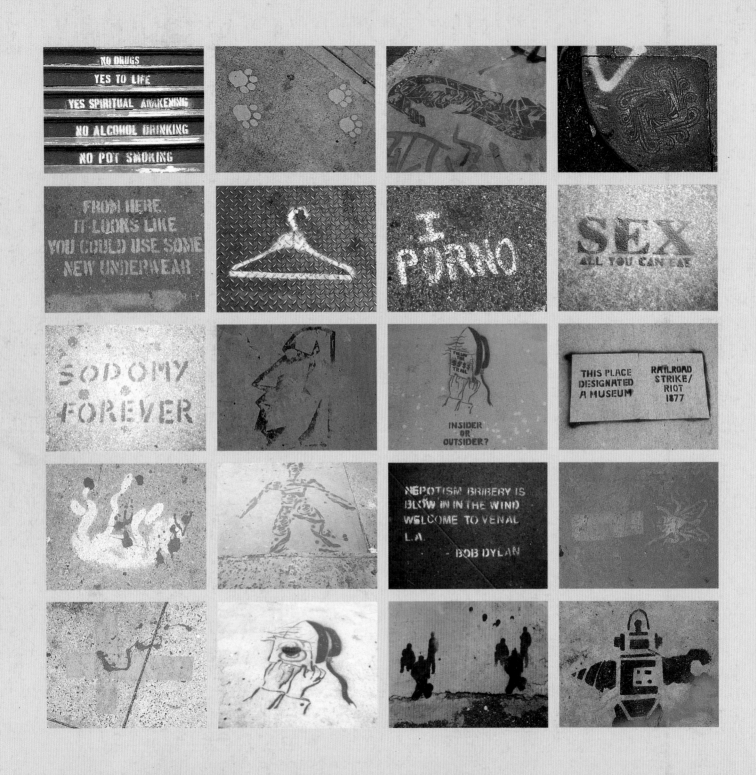

TRISTAN MANCO

STENCIL GRAFFITI

Thames & Hudson

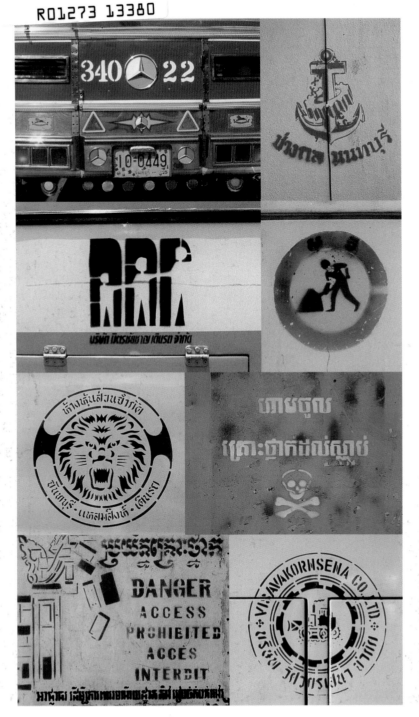

IN MEMORY OF JULES BACKUS

In 1993, attracted to the cracked and crumbling walls of Paris and the stencilled images he encountered there, American artist and photographer Jules Backus began a series of photographs of Paris stencils that was the focus of his work for the last four years of his life. His legacy of beautiful photographs was kindly made available for this book by Mary Peacock, his partner and curator of the touring exhibition of his work "Ambush in the Streets."

p. 1 Typewriters by Pablo Fiasco; artwork by Nicola Medlik

p. 2 Top row: Steps, Greenwich Village, New York; Pawprints on pavement, New York; 3-D stencil by Paris, Bedminster Skate Park, Bristol; Op Art, Brighton; 2nd row: New Underwear pavement stencil, New York; Anti-Abortion, New York; I Love Porno, New York; Sex: All You Can Eat, New York; 3rd row: Sodomy Forever, New York; Easter Island Statue, Bedminster Skate Park, Bristol; Insider or Outsider?, Art Activism by CCC, Baltimore; Designated Museum, Art Activism by CCC, Baltimore; 4th row: Anti-Abortion, New York; Figure on pavement, New York; Venal LA, Los Angeles; Fly Exclamation, Barcelona; Bottom row: Show Off, Brighton; Art Activism by CCC, Baltimore; Three figures, Bedminster Skate Park, Bristol; Robbie the Robot, Bedminster Skate Park, Bristol

p. 3 Cutting board

This page: Top row: Bus numbers, East Thailand; Electronics company sign, Thailand; 2nd row: Bus, East Thailand; Men at Work, stencil on truck, Thailand; 3rd row: Taxi company, East Thailand; 'Danger, Death', electricity warning, Cambodia; Bottom row: Danger notice, Angkor Wat, Cambodia; Bus company, Thailand

Opposite: Che stencil, Chiapas, Mexico

© 2002 Tristan Manco

First published in paperback in the United States of America in 2002 by Thames & Hudson Inc., 500 Fifth Avenue, New York, New York 10110

thamesandhudsonusa.com

Library of Congress Catalog Card Number 2001096301
ISBN 0-500-28342-7

Printed and bound in China

CONTENTS

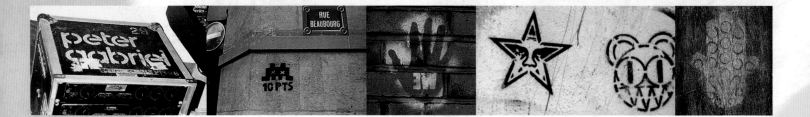

IN A WORLD SATURATED WITH HIGH-PRICED CORPORATE IMAGERY, BEYOND JUST HAVING A CHARMING AESTHETIC, THE STENCIL IS A CHEAP AND EFFECTIVE WAY FOR AN ARTIST OR ACTIVIST TO PUT THEIR WORK IN FRONT OF THE PUBLIC AND LEVEL THE PLAYING FIELD

Shepard Fairey

STREET STENCILS ARE BEAUTIFUL LITTLE BOOBY-TRAPS OF INFORMATION LYING IN WAIT; AESTHETIC GIFTS LEFT BEHIND AS URBAN FOLK ART, SIMULTANEOUSLY REVEALING AND CONCEALING THEIR PURPOSE

Western Cell Division

WRITING GRAFFITI IS ABOUT THE MOST HONEST WAY YOU CAN BE AN ARTIST. IT TAKES NO MONEY TO DO IT, YOU DON'T NEED AN EDUCATION TO UNDERSTAND IT AND THERE'S NO ADMISSION FEE.

Banksy

MY DRIVE IS THE NEED TO SEE ART ON BLANK SPACES, TO BREATHE LIFE INTO DERELICT SITES. IT OFTEN MAKES PEOPLE THINK TWICE ABOUT VANDALIZING THEM, JUST AS YOU WOULDN'T THROW A PIECE OF WOOD ONTO THE FIRE IF IT WERE CARVED INTO A BEAUTIFUL FIGURE OR ANIMAL.

Nylon

THE IDEA OF USING THE URBAN LANDSCAPE AS A CANVAS REMAINS CONSTANT. IF YOU WANT TO GET YOUR POINT ACROSS THERE'S ONLY ONE WAY TO DO IT: GET YOUR MESSAGE TO WHERE THE PUBLIC CAN SEE IT. POSTER, STICKER, STENCIL AND COVER THE STREETS, SIGNS, WALLS AND WHATEVER ELSE IS OUT THERE.

Dave Kinsey

WHAT INTERESTS ME IS THAT A STENCIL IS 'OPEN': ONE PERSON WILL SEE ONE THING, ANOTHER SOMETHING ELSE. THE MORE PEOPLE SEE DIFFERENT THINGS IN MY POCHOIRS, THE MORE I 'WIN'.

Némo

INCOMING

Street art is both an expression of our culture and a counterculture in itself. 'Communication' has become a modern mantra: the city streets shout with billboards, fly posters and corporate advertising, all vying for our attention. They almost invite a subversive response. As high-tech communications have increased, a low-tech reaction has been the recent explosion in street art.

The street is a unique and powerful platform; a frontline on which artists can express themselves, transmitting their personal visions directly to the public at the same level as official messages. No other art form interacts in this way with our daily lives, using our urban space as its surface.

In parallel with the accelerated communications of modern technology, images and ideas are spreading like viruses over walls across the world. These walls are experimental, uncensored and collaborative spaces, and the simple and effective beauty of stencilled graffiti offers great scope for expression, from protest art to poetry. There is a global new wave of artists who are discovering and expanding the possibilities of the medium. This new work is strong in both form and ideas, using humour and irony to convey important and thought-provoking messages about today's society.

Street arts are hybridizing, too. Inspired by street works, artists are increasingly using stencils on canvas, metal, T-shirts, textiles, paper and in the digital realm. Designers of all kinds, fine artists and graffiti artists are expanding horizons with mixed media applications. Often multi-disciplined, today's stencil graffiti artists are using stencils with fly posters, stickers, collage and freehand painting, using spray- and other paints, in ever-mutating and creative ways. Showcased here are over 400 examples of contemporary stencilled works, their innovation and vitality achieved with new materials, methods and approaches.

Many of these photographs are time capsules of city walls, a great number of which have since been knocked down or the images on them been destroyed. Each city's street architecture has its own colour and feeling, and each wall tells a unique story. Settings and situations give a flavour of a location, and there is always a beauty in the ghostly quality of the stencilled image against the tints and textures of a town's decaying walls.

The aim of the book is to take a worldwide look at stencil art, its history, its applications in commercial art, its relationships to street signage, the urban environment and other forms of graffiti.

The book is dedicated to the pioneers and to the new movement of street and graphic artists who are pushing the form with new styles and techniques, both on and off the streets.

HISTORY OF STENCIL ART

A stencil is essentially a template which can be painted through with a paint-brush or spray-paint. It is thought to be one of the earliest art techniques and its origins go back to cave paintings produced around 22,000 years ago. Alongside silhouetted anthropomorphic figures, hand silhouettes were produced by blowing paint around a hand placed on a surface to create an inverted imprint. This simple idea proved very adaptable throughout history and across the globe.

Opposite left to right: Peter Gabriel flightcase; Space Invader, Paris; Hand stencil, London; Obey Star by Shepard Fairey and Radiohead stencil, Melrose, California; Hand of Fatima, Paris; background, portrait of Nylon Below left to right: Viva Zapata, Barcelona; Louis Armstrong, Paris; 'Post No Bills', Paris; Heart, Brighton

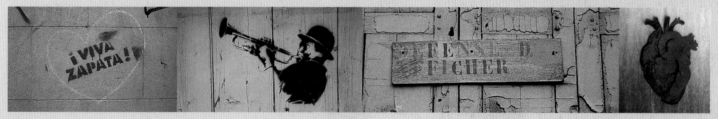

Above left to right: Buster Keaton by Blek, Paris; El Choquito (The Squid) by Nano4814, Brixton, London; Obey Giant by Shepard Fairey, Hong Kong

Leather and papyrus templates were used to decorate the inner walls of the Egyptian pyramids. The Chinese cut stencils from paper to decorate silk with Buddha figures and ornamental devices. The method travelled from Asia to Europe and was used as a decorative technique from the medieval period through to the 1930s on church walls, floors, furniture, textiles and wallpaper.

During the Art Nouveau and the Art Deco periods, the technique of *pochoir* (the French word for hand-colouring by means of stencils) was developed in France for limited-edition prints and posters. The *pochoir* method was an extremely costly and laborious process in which a design was built up with metal stencils, each coloured by hand using gouache paint, creating the illusion of watercolour or oil paintings.

In the 1930s the more sophisticated stencil process of screen printing was developed as a means of mass-producing artwork. Screen printing uses a silk screen which allows ink to go through mesh; blocked areas are resisted. Chemical and photomechanical processes enabled artists to create more complex designs than was possible with ordinary cut-out stencils.

By the late 1950s and '60s, American artists like Robert Rauschenberg and Andy Warhol had developed new screen-printing techniques and visual ideas that had a great impact on art and design. Warhol, in particular, was a Pop art pioneer: his work used the flat, vivid colours of product packaging to make iconographic images inspired by commercial art and popular culture. Rauschenberg also used mass-media imagery, as well as found and personal photography, but his work was more expressive and hand-made than pure Pop. In his screen-print work he experimented with different textural surfaces, adding hand-painted areas and collage-like overlays to create new fusions. Even if they did not use actual stencil templates, both Warhol and Rauschenberg, with their hybrid of techniques and Pop imagery, are forerunners of today's stencil artists.

Stencilling is still used as an interior decoration method and, more functionally, as a graphic method for printing and signage, from packaging to traffic notices. Appropriating this technique, graffiti artists also use stencils to communicate their ideas in a free and ephemeral form of artistic expression.

HISTORY OF STENCIL GRAFFITI

The origins of stencil graffiti are often associated with the Latin countries of Southern Europe and South America. During the Second World War, Italian fascists used stencils to paint images of Il Duce as propaganda. The Basques and the Mexicans used the same technique in protests during the 1970s. From these roots, stencil graffiti developed into a true art form.

In Paris, in the early 1980s, the strong traditions of protest art combined with an Art Deco decorative tradition and many other factors to produce something completely new. One of its originators and innovators was Blek le Rat, who came across the *pochoir* method while studying at the Ecole des Beaux-Arts, famed for its role in the 1968 Paris strikes. The Atelier Populaire was formed there by the faculty and students of the lithographic department to produce the first poster of the revolution.

Blek felt himself connected to this legacy but his inspiration came when he and a friend, Gérard, were working at an adventure playground for youngsters. The playground was just behind a supermarket, from which aerosol cans were being 'liberated' and used to decorate the cabin where the pair were storing their gear. Having been bitten by the bug, Blek and Gérard decided to get themselves some cans. Their first attempts at spray-can art were crude, so Blek, who remembered seeing the image of Mussolini on walls in Italy during his childhood, suggested stencilling. They chose the name 'Blek' as a reference to a cartoon book.

At the time Paris was like a blank canvas. From 1982 onwards the duo became bolder and bolder in their sorties, and on New Year's Eve they hit that shrine of the art elite, the Pompidou Centre, with a plague of rats, tanks and figures. At the end of 1983 the partners separated and Blek took the pseudonym for himself.

Blek's enthusiasm for the art form soon ignited a whole movement. During summer 1984 other stencils began to appear in Paris. The first were signed 'Marie Rouffet' and 'Surface Active'. Blek describes this development: 'It was a new kind of language and a dialogue developed between us. This is now one of the main reasons that I work in urban space. I had a presence for thousands of people who I didn't know and would never meet, and yet I had a firm feeling of existing and speaking to them out of the anonymity and isolation of urban surroundings.'

Blek and Jérôme Mesnager, another Parisian pioneer of street art, went on to spread the idea, travelling across Europe and to New York.

Blek painted works on the Leo Castelli Gallery and other strategic points, and Mesnager plastered them everywhere.

As a movement, stencilling and other forms of street artwork took off in New York in the early 1980s – a result of the boom in gallery art and, in part, the arrival of the art school new wave and punk. The modern concept of graffiti was conceived in New York and the term is still most strongly identified with 'hip-hop' or 'New York style' graffiti. The first 'tags' (usually names or nicknames) appeared around the city in the late 1960s. By the '70s these had become bigger, turning into 'pieces', short for 'masterpieces'. They then began to include more pictorial elements, as well as increasing innovations in typography and style. The movement soon became international and its styles and forms continue to develop and mutate. Today it is the dominant form of graffiti and so has appropriated the term.

Graffiti, however, is a vast subject with its own references, languages and forms. In this book I describe graffitied stencils as 'stencil graffiti' but not everyone would agree with this definition. Graffiti art, as an idea, has always existed alongside other artistic endeavours, the difference being that it is a mode of self-expression using methods that are seen as criminal, or outside the conventional art world, rather than specifically sanctioned or commissioned art.

Graffiti (*sgraffiti*), meaning drawings or scribblings on a flat surface and deriving from the Italian *sgraffio* ('scratch'), with a nod to the Greek *graphein* ('to write'), originally referred to those marks found on ancient Roman architecture. The term is now associated with the twentieth-century urban environment, where it covers anything from simple marks to complex and colourful compositions. This broad definition includes all styles from tags to political graffiti, and all methods from spray-cans, paint-brushes and marker-pens to stickers and stencils.

Within all graffiti activism there tend to be both destructive and creative forces. Some graffiti is over-ridingly about defacement – window-scratching, tagging and throwups (usually rapidly executed bubble letters or simple pieces using few colours). These are specifically aimed at getting the most coverage possible. Although some defend this activity as an issue of free expression or claiming of public space, most people would condemn its destructiveness. With the more creative forms, such as graffiti pieces and stencil graffiti, there tends to be more respect for

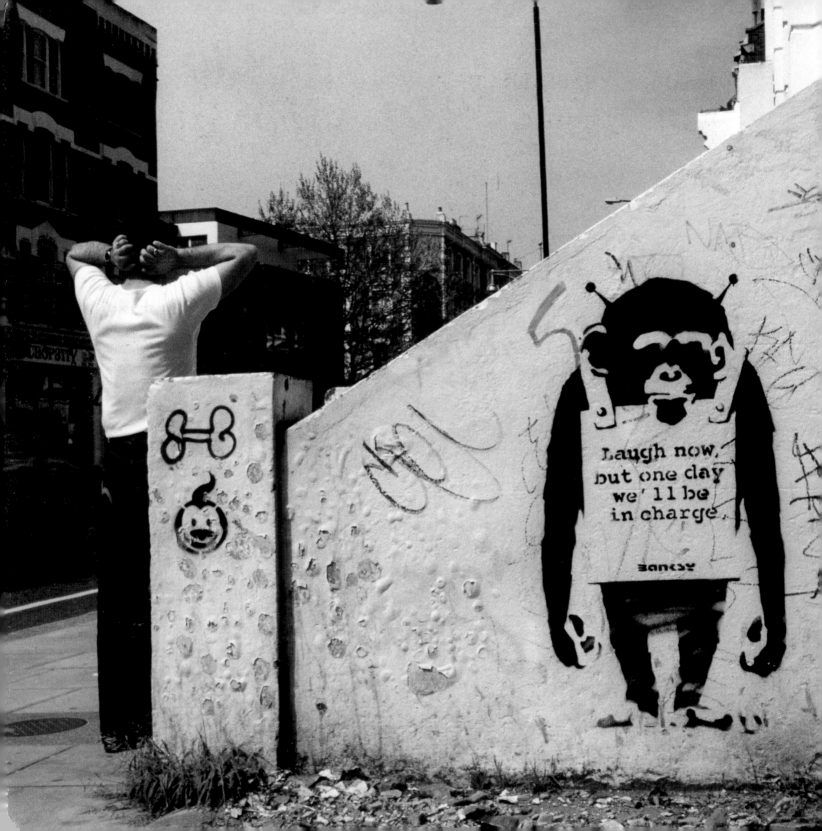

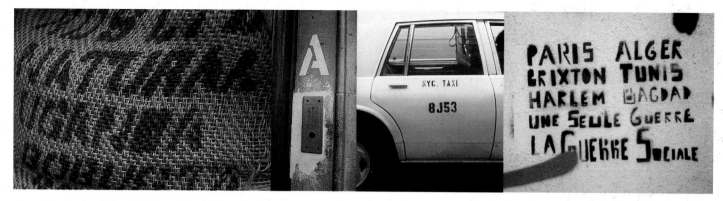

Opposite: Laugh Now by Banksy, Ladbroke Grove, London Above left to right: African coffee sack; Apartment signage, Paris; NYC taxi, New York; 'Social War', Paris

private property and culturally significant or beautiful buildings, which amounts to self-policing on the part of artists as to choice of location.

In the 1980s graffiti legislation and policing was in its infancy. Today, in cities across Europe and the USA, council policy-makers have more control of the streets, with the power to create legal sites or to legislate for zero tolerance. For many stencil artists this results in participation in a cat-and-mouse game to create illegal acts of creation in the name of art and freedom of expression.

At the present time, stencil graffiti is enjoying a resurgence. While some of the first generation of Parisian artists, such as Jérôme Mesnager and Némo, are still creating new works in increasingly far-flung territories, in the last few years a new generation has discovered the technique and made it their own. Stencil art has spread far across the globe, finding new footholds in South America, Eastern Europe and Africa. It is the immediacy of this art which keeps it fresh; its ability to communicate to people, freely and with good humour, that makes it an antidote to mass media and corporate advertising.

Though stencils are essentially ephemeral and wear away with time, they tend to have a longer lifespan than other forms of graffiti, as they are found in more considered locations – in older neighbourhoods or condemned buildings. They often survive council clean-ups, left alone, not seen as graffiti but perhaps as public notices or murals. This is not to say that stencils are more permissible than any other graffiti, but it does point to the issue of placement of street art. Placement is crucial for the artist to be able to communicate symbolically, politically and artistically to an audience. Various factors come into play, such as the size of the piece, who the audience is and what impact the piece has on the environment.

Many stencil artists feel strongly about this issue of location and make quite conscious decisions about where and to whom they want to communicate. Jérôme Mesnager and Némo choose to make work in living communities, such as their own in Montreuil on the outskirts of Paris, rather than the more bourgeois and commercial *arrondissements*. They aim to bring visual life to the local inhabitants – working people, schoolchildren – of run-down areas.

Stencils are more self-conscious than the spontaneous tagged graffiti messages or the coded confidence of hip-hop style. A stencilist will have a location in mind for both aesthetic reasons and for an audience. Generally the artists have an affinity with the place they choose, they know its aspect and have considered its qualities of colour, shape and surface. Some choose a humble spot, perhaps an old, disused door with aged and peeling paint. The audience in this case will be small but, when stumbled upon, the piece will feel like a hidden treasure. Other stencilists pick locations for their associations, for example Serge Gainsbourg's house in Paris (see p. 29). Fashionable districts are also popular sites for art-based stencils since they will be seen by young people, the media and perhaps galleries. Stencilist activists tend to want to communicate to wide audiences so they target shopping districts or government buildings.

Hip-hop graffiti artists also create community pieces but, due to space restrictions, their more experimental works tend to be in locations that are difficult for the public to access. However, it is not always useful to compare 'graffiti' and 'stencil graffiti'; they are very different, although stencil artists are not necessarily a breed apart.

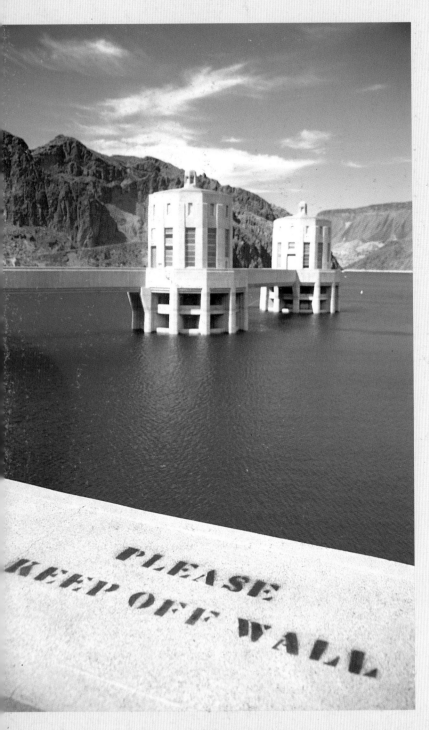

Stencil graffiti is not an exclusive realm. Some graffiti writers use it simply as an element – a feature or a detail – in their pieces: Balzi in São Paulo uses it along with collage and free painting. For other artists, like Nano from Vigo, it is just one method in an experimental repertoire of graphic techniques. Sometimes graffiti writers have alter egos as stencil designers. Nylon, for example – a well-respected UK graffiti writer – makes stencils under the names of 'Sucre' and 'Shar'. Different techniques are simply tools for different kinds of work.

I refer to people making stencils as stencilists, but this does not mean that these people necessarily affiliate themselves with any particular movement. Graffiti artists and stencil graffiti artists coexist and influence each other, and as the pieces and messages of both genres develop and expand beyond recognizable boundaries, much of today's work is best described in more general terms as 'street art'.

STENCIL STYLE

The attraction for all stencil artists – old and new, on the street and off – is that, as well as being a great method of communication, stencilling also has an enduring aesthetic appeal.

Stencil style is graphically associated with the sort of functional type long found on packaging, and is thereby also associated with authenticity, natural materials and an authoritative message. In the twentieth century, this utilitarian lettering process influenced typeface fashion, with professional typographers imitating the vernacular style. Tea Chest, a font designed in 1936 by Stephenson Blake, was an early example. In the Bauhaus school, Josef Albers developed the Kombinationsschrift alphabet – a utilitarian set of typefaces, consisting of ten basic permutations of the circle and the rectangle, which were by design ideal for stencilling. Today's UK type designers Swifty and Mitch continue this tradition, taking stencil type as practical inspiration, and creating hybrid fonts of retro, future and non-latin forms with rough stencilled edges.

Functional stencils are a good introduction to stencil graffiti. They both share the same urban space and have similar visual properties. Unlike stencil graffiti, however, functional stencils are seen as legitimate communication, not as damage to property. Looking at the usage and aesthetic of this work is therefore a good point of comparison between graffiti works.

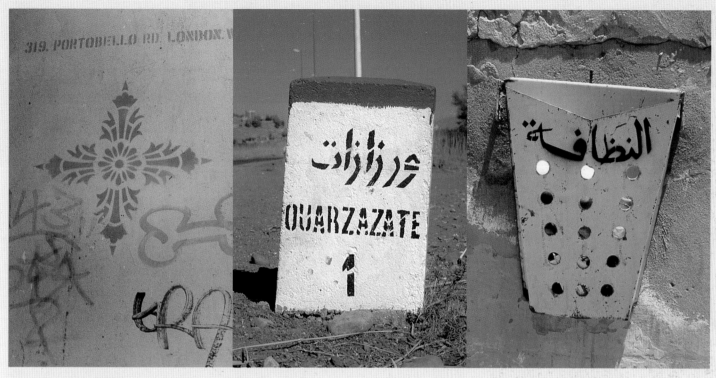

319. PORTOBELLO RD. LONDON.

ورزازات
OUARZAZATE
1

النظافة

Opposite: Hoover Dam, Nevada Above left to right: Decorative stencil, Portobello Road, London; Road sign, Morocco; Trashcan, Morocco

As public signage, stencils are well-suited to the physical properties of the city and the man-made structures of stone, metal and wood. Stencil signage is an art form in itself, with its own graphic language and conventions of colour, form, design and typography. It is also specific to a city's own architectural, cultural and design history. Street names and direction signs are vital components of a location. Public lettering is not just a question of large type but is a relationship of lettering to buildings or immediate surroundings. Signs need to be read but, for any sign system, an aesthetic integration with the environment also has to be considered.

Stencils are often used as a low-tech practical method of signage for temporary sites like roadworks or more permanent sites when economy and materials dictate them to be the easiest method. These stencils need to be clear and instructive – arrows pointing out directions; messages in simple, sometimes single words. Consistency is also important. So the New York taxi numbering system (see p. 11), for instance, is consistent in the positioning and size of type and numbering.

Words get noticed because they convey information. Words inform, record, forbid and direct us. When used for official notices, stencilled text – the spacing, the aesthetic of the letters and numbers – tends to have a precise, military authority that blends with street architecture.

Stylistic conventions, however, also make up a language referenced and plundered in other forms of stencil art. Utilitarian style has been appropriated by British artist Banksy in his messages parodying official city council notices. These messages have included 'Beware Trapdoors in Operation' and 'This Wall is a Designated Graffiti Area' (see p. 77), the latter so convincingly rendered that newly whitewashed London walls have, within days, become covered in graffiti.

Stencils have a long association with rebellion and punk. The punk movement used stencils because they fitted the general D.I.Y philosophy and were a reference to utilitarian and military style, which punk appropriated to subvert symbols of authority. The movement also flirted, in a subversive way, with images and ideas of fascism and communism;

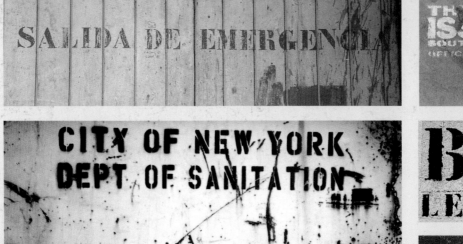

SALIDA DE EMERGENCIA

THE BIG ISSUE SOUTH WEST OFFICIAL PITCH

CITY OF NEW YORK DEPT OF SANITATION

BADA LETRA C

320

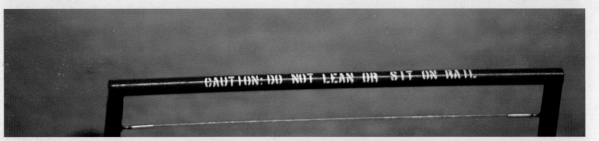

CAUTION: DO NOT LEAN OR SIT ON RAIL

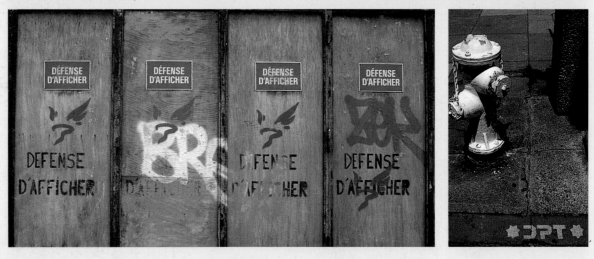

DÉFENSE D'AFFICHER

DEFENSE D'AFFICHER

DPT

Top row: Emergency exit with Keith Haring tag, Barcelona; *Big Issue* magazine pitch, Bath; 2nd row: Recycling skip, New York; (above) Signage, warehouse, Barcelona; (below) Numbering, builders yard, Paris; 3rd row: Baseball pitch rail, Texas Rangers Ball Park, Arlington, Texas; Bottom row: 'Post No Bills', Paris; Pavement signage, New York

Opposite left to right: Figure with Eckō clothing brand rhino stencil, New York; Various advertising stencils, London; Doodlebug promotions by Barney Barnes, Manchester; S&H logo by Stoloff & Hopkinson, Bristol

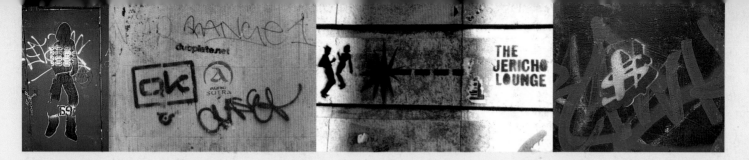

anarchy became the punk philosophy. This rebel spirit accounts for stencil activism in cities with strong countercultures such as Berlin and Barcelona.

Protest stencils tend to be rough and urgent, with typically bold red lettering and strong iconic imagery, such as the raised fist. The reductive iconography necessitated by the stencilling process means that artists generally try to get their message across with one simple image, its line and construction carefully considered.

The other important stylistic feature of stencilled art is its immediacy, which is part of the general compositional over-layering that occurs with graffiti. As San Diego artist Shepard Fairey puts it, 'the image is integrated with the texture of the street'.

Designers and artists in all fields use stencils for their various associations and for their textural and design qualities. Off-street artists also take inspiration from the patchwork surfaces and random compositions of the urban environment by layering processes of their own with paint and other materials or with reprocessing techniques such as digital manipulation. Fine artists like Jean-Michel Basquiat and Jean Dubuffet, for example, were directly inspired by the textures and symbols of street art. Others, however, agree with Blek's comment: 'When this art is taken away from the streets, somehow it dies.'

In recent years stencils have become the *de rigueur* medium for promotional campaigns. In terms of fashionability they may already have passed their sell-by date as they become more ubiquitous. While graffiti has been used on the clothing and accessories of today's most desirable fashion houses, including Louis Vuitton and Luella Bartley, stencils in particular have been used to promote everything from club nights, bands

and record labels to websites and even multinational companies. Corporate advertisers see stencils as an inexpensive and alternative way of spreading information, while having an element of street credibility. It is debatable whether, by adopting street tactics, brands become in any way more credible but this method can target particular groups very effectively – if one hits the right locations. Particular hot spots are in skate parks and near nightclubs. There is, for example, a particular style of commercial stencil to be found on the streets of New York: it is sprayed on the pavement. The advantage of this approach is that it does not vandalize private property and, with the huge amount of pavement traffic, it has a very short lifespan. Promoters and advertisers often employ stencil artists to undertake the covert campaigns – which is ironic as they are often the most disparaging towards corporate stencils encroaching onto their creative territory.

Manchester-based designer and promotor Barney Barnes produced a campaign for his club night 'Doodlebug', which began on pavements, with dotted lines leading to an image of an explosion. Days later these lines started creeping up walls leading to the venue's name.

Bristol-based experimental electronics act Stoloff & Hopkinson use stencils to poke fun at global branding by turning their initials S&H into logos that look like those of powerful corporations, and into the dollar sign (see above).

In the end, whatever the message or motivation, all stencils become part of our environment. As they become absorbed into the city walls and as we discover them, they become part of our experience; they become, ultimately, part of us.

Previous pages: Wall, London
Opposite: Moped, Madrid
Left: Repeated Model, Prague
Below: Sucre Models by Nylon, Brighton

Whereas hip-hop graffiti evolved from the written letter, the majority of stencil graffiti is essentially iconographic or pictographic. The physical limitations of stencils mean that simpler shapes are more definitive, fewer areas bleed and the end result is more effective. This reductive process in terms of image focuses the artist to the essence of an idea. In this way single iconic representations best suit the medium.

Stencilists have appropriated the idea from Dada and Pop that images of popular culture or commonplace objects can be art. A cultural phenomenon of the late 1950s and '60s, Pop art rejected the supremacy of 'high art' and the pretensions of the avant-garde. Its iconography was aimed at narrowing the distance between art and life by celebrating the mass-produced objects of the time. Pop art is sometimes seen as impersonal – presenting images without praise or condemnation – or as social criticism. Warhol's repetitions, for example, can be viewed as a commentary on mass-production.

Today's stencilled Pop art is usually rather quirky and humorous, and does not necessarily stem from the same motivations as the original Popsters' work. Stencils take Pop out of the gallery and into the world, where the art plays with its surroundings. The surprise element comes from finding an image of, for example, a cow or a toaster or any number of obscure items on a wall, and from the fact that these images have been produced in the public arena, where most messages tend to be corporate or functional. There are many visual twists in these appropriations and a subversion in even the most innocent images. On the whole, though, the selection shown here is a light-hearted celebration of iconic imagery.

The other reason for artists choosing icons is the affinity that they share with their subject: it is the passion for the icon that inspires them to share it with the world. This is Pop art from the heart, inspired by, say, a favourite animal or vegetable. Everyone is passionate about something. For many artists, this is the first kind of stencil they try out. It may be the one and only stencil they make. Or they may simply do it for the enjoyment of creation.

This collection, showing influences from cult films like *Blade Runner*, enigmatic heroes like Salvador Dalí and style-conscious totems like record decks, is an insight into global heroes and obsessions. The stencils range from very slick, streamlined, multi-coloured designs to crude, simple ideas with an anti-fashion charm.

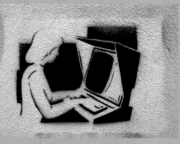

OBJECTS

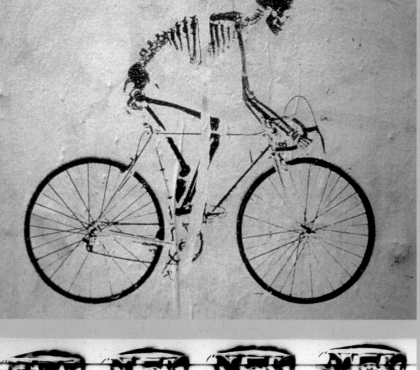

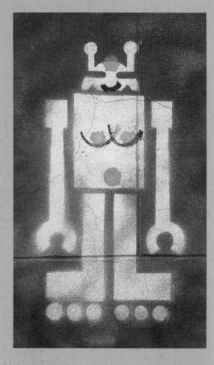

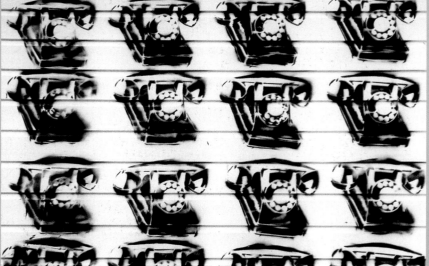

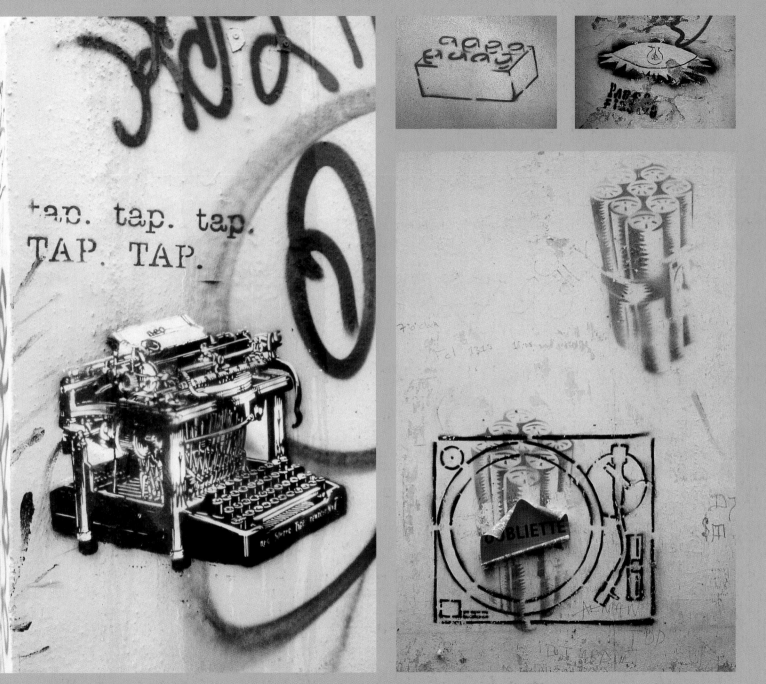

Opposite, clockwise from top left: Computer Operator, Bristol; Skeleton Cyclist, Paris; Telephones by Circa, Brighton; Motorcycle, London; Robot, Bristol
Above, clockwise from left: Typewriter by Pablo Fiasco, Brighton; Lego Brick by Andy Stott, Bristol; Lightbulb by Pablo Fiasco, Brighton; Record Deck and Dynamite, London

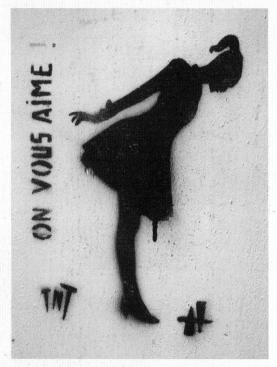

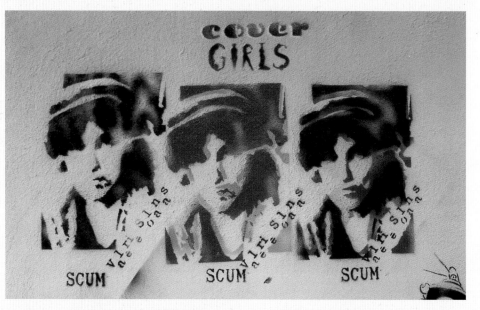

Clockwise from left: 'We Love You' by TNT, Paris; Cover Girls, Brighton; Mandy Warpole by Scumfuck, Brighton; Model, Paris; Kiss, Bristol

SEX OBJECTS

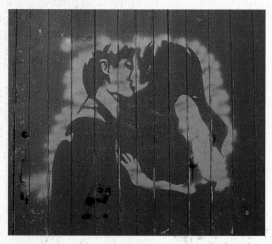

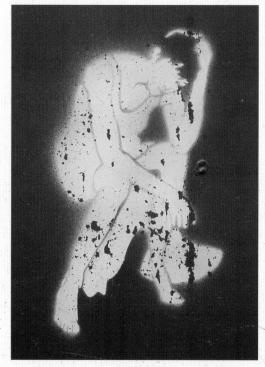

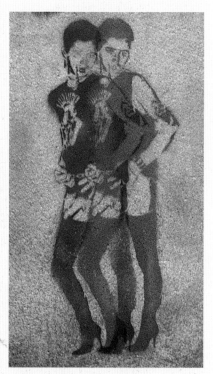

Opposite, above left to right: Nude, Paris; Embracing Couple, Paris; Kiss by TNT, Paris; Model by Nice Art, Paris
Below: Underwear Models by Circa, Brighton

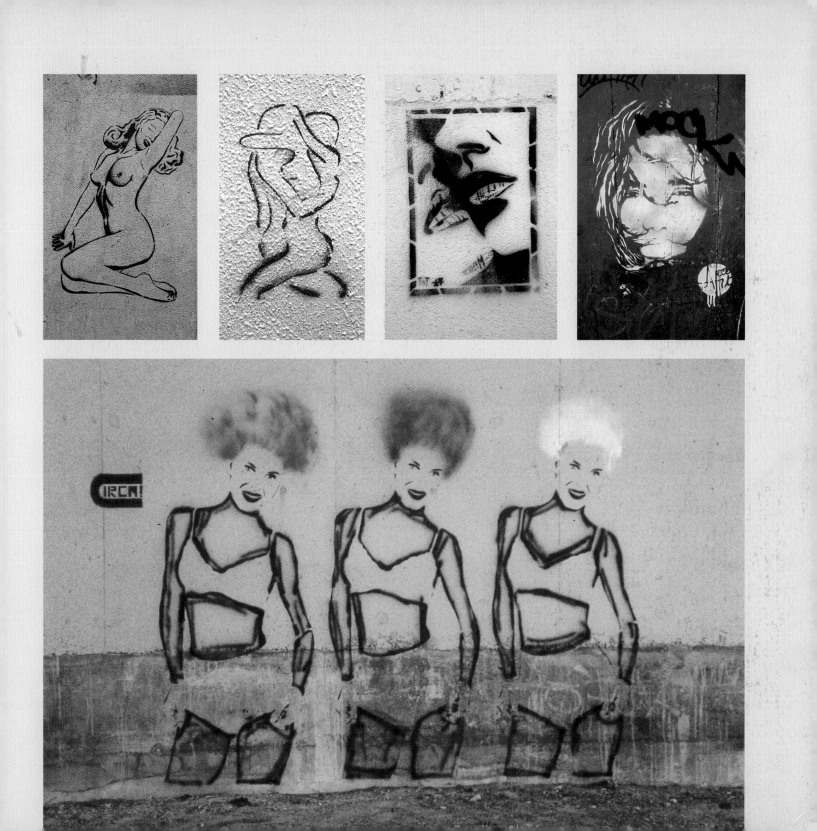

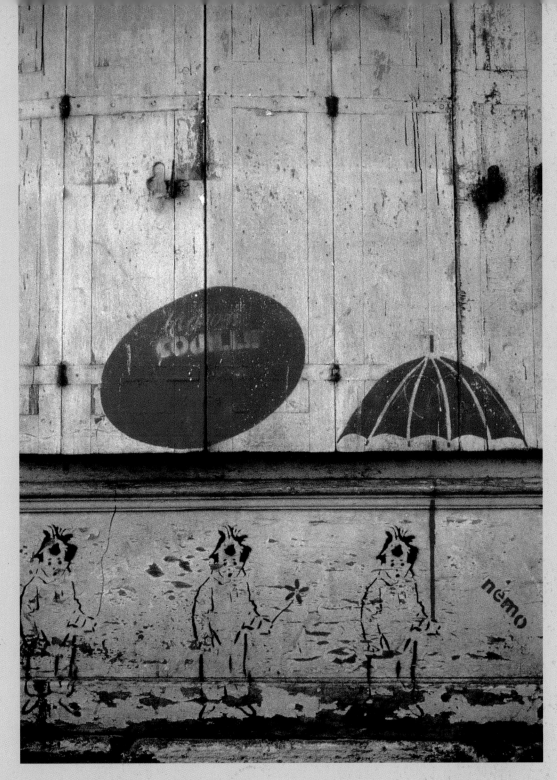

Opposite left to right: Storm Trooper, Bristol; Flash by Par 3, Bristol; Frankie Say Revolt, Brighton; Hulk by STR Crew, Bristol; background, Big Boss by STR Crew, Bristol
This page, left: Little Némo by Némo, Paris; Below: Silver Surfer, Paris

COMICBOOK HEROES

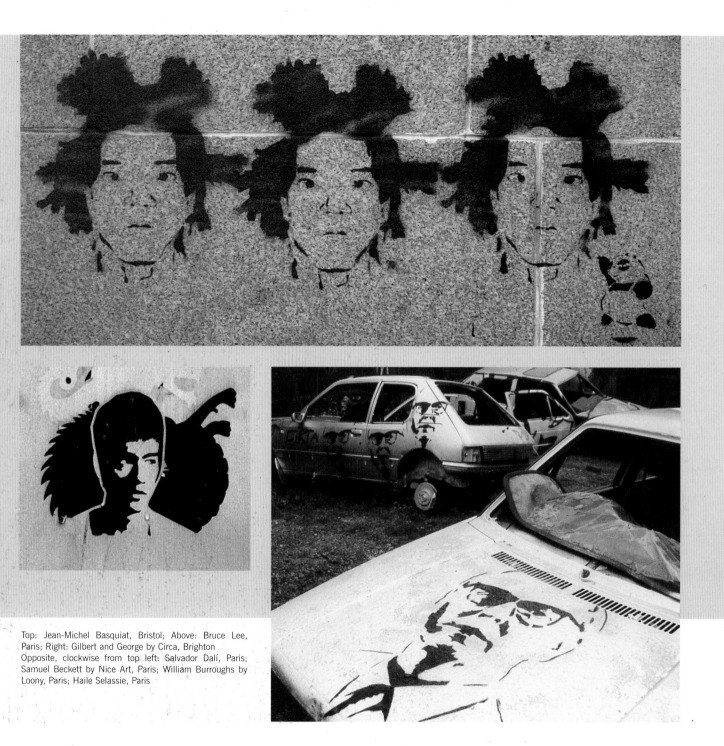

Top: Jean-Michel Basquiat, Bristol; Above: Bruce Lee, Paris; Right: Gilbert and George by Circa, Brighton
Opposite, clockwise from top left: Salvador Dalí, Paris; Samuel Beckett by Nice Art, Paris; William Burroughs by Loony, Paris; Haile Selassie, Paris

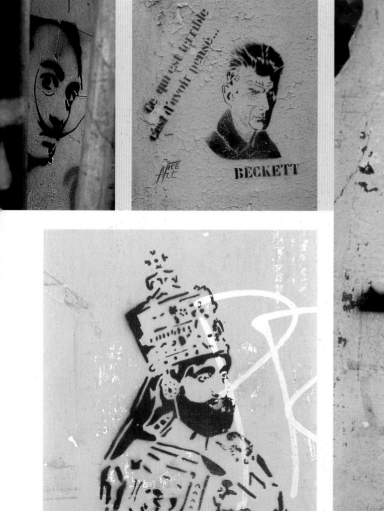

BECKETT

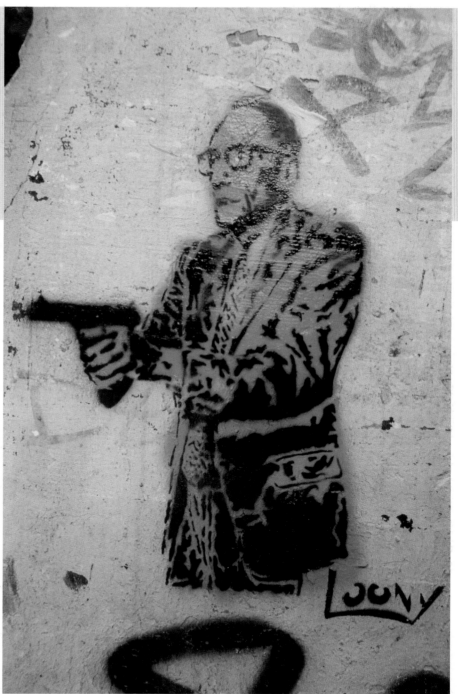

CULT HEROES

CRY A RIDER
for Jackie Opel

Boogie With The

Godfather Of Ska

In Memory Of

Tommy McCook
1927-1998

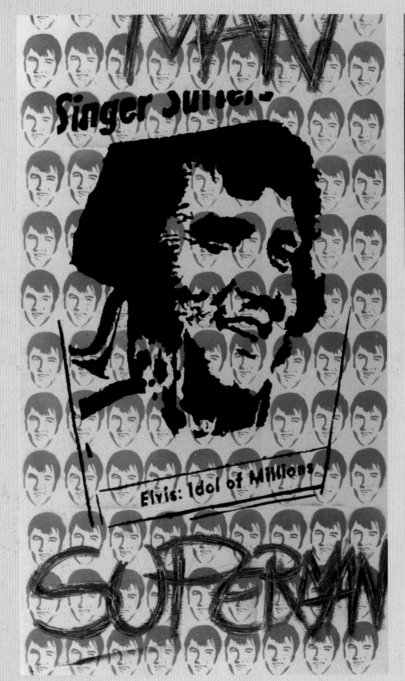

Singer Sunter-

Elvis: Idol of Millions

SUPERMAN

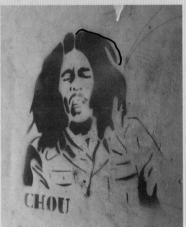

CHOU

MUSIC
LEGENDS

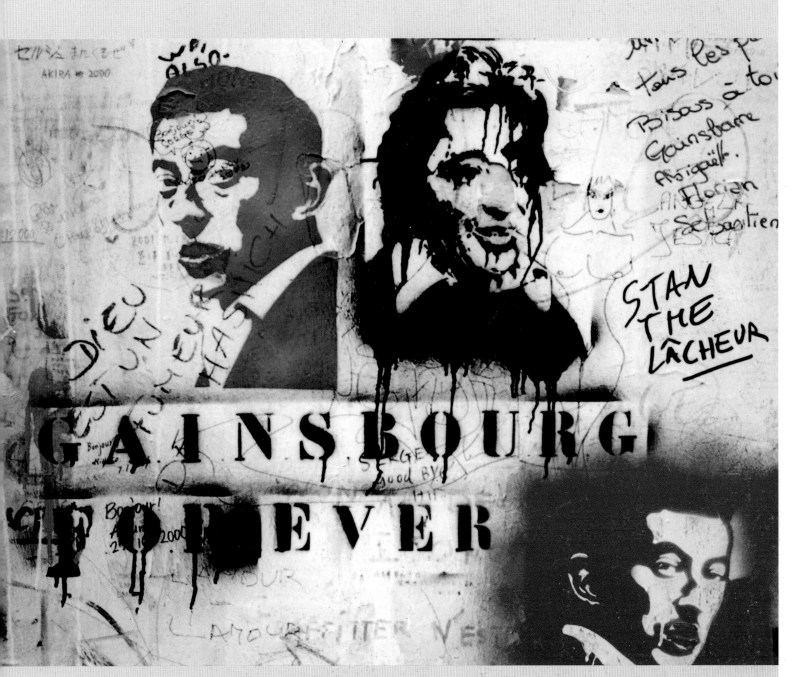

Opposite, clockwise from top left: Jackie Opel by Hao, Paris; Elvis by Wack, Manchester; Johnny Rotten, Bristol; Bob Marley by Chou, Aachen; Tommy McCook by Hao, Paris; Laurel Aitkin by Hao, Paris Above: Serge Gainsbourg's house, Paris

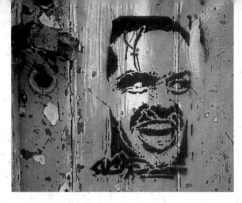
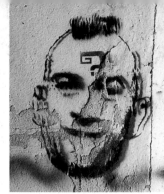
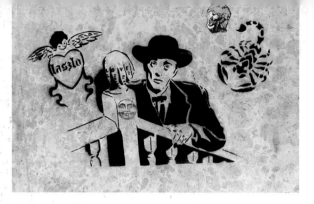

SCREEN STARS

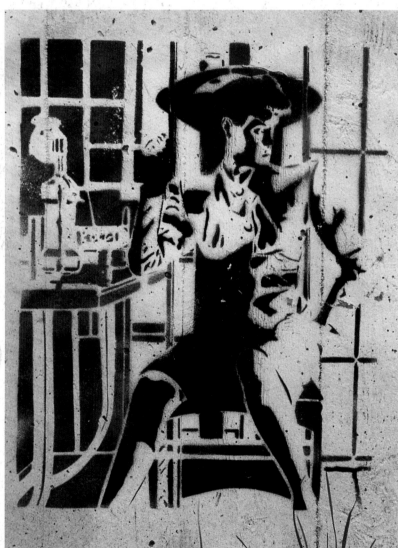

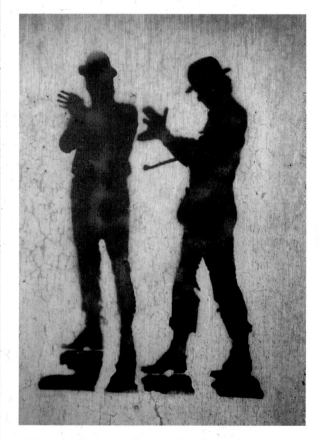

Clockwise from top left: Jack Nicholson, *The Shining*, by Nylon, Brighton; Robert De Niro, *Taxi Driver*, Brighton; Robert Mitchum, *Night of the Hunter*, by Laszlo, Paris; *A Clockwork Orange*, Bristol; Rachel, *Blade Runner*, Bristol

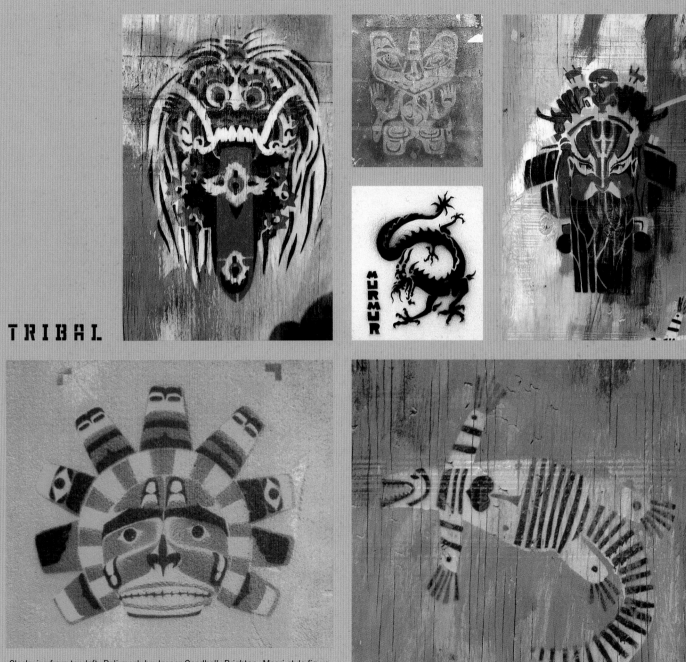

TRIBAL

Clockwise from top left: Bali mask by Jaspar Goodhall, Brighton; Maori-style figure, Montpellier; Japanese-style mask by Jaspar Goodhall, Brighton; Crocodile motif by Jaspar Goodhall, Brighton; North West Indian-style mask by Jaspar Goodhall, Brighton; (centre) Dragon by MurMur, Paris

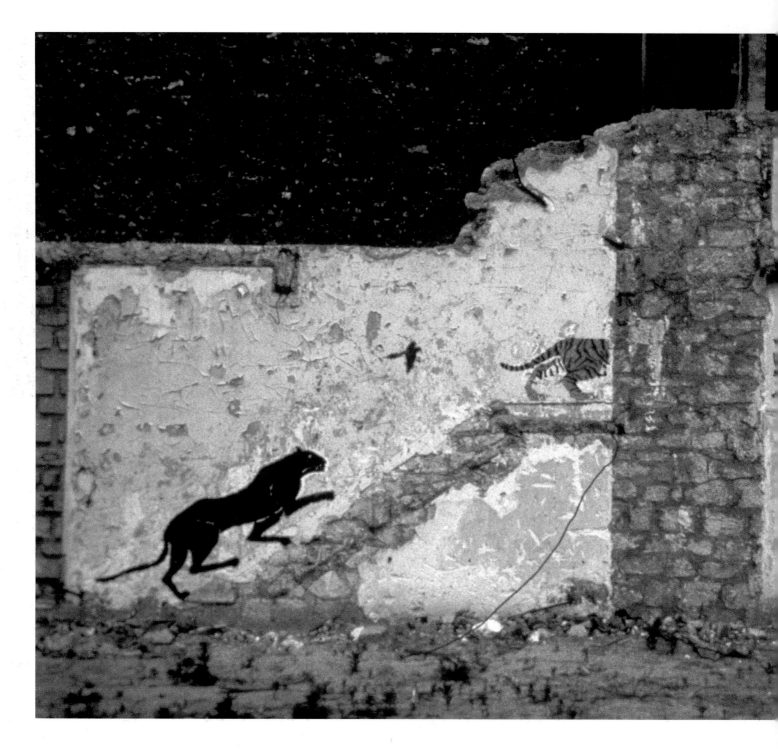

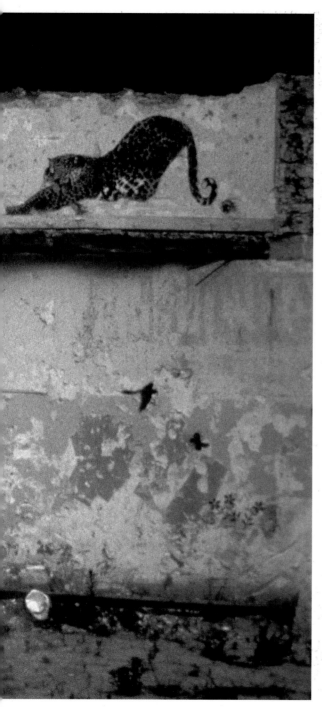

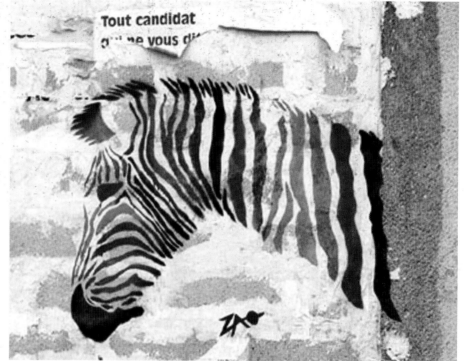

Tout candidat
qu ne vous di...

Z00

Opposite: Zoo by various artists, Paris
Above: Zebra by Zao, Paris
Left, top row: Ants, Barcelona; Beatle, Barcelona
2nd row: Butterfly, Rue de Papillon, Paris; Jumbo by Tristan Manco, Bristol; Lizard, Paris
Bottom row: Dog, Lisbon; Cats, Barcelona; Panda, Bristol

Following pages:
Banksy spraying artwork

MAKE YOUR MARK

There are as many approaches to stencilling as there are to any other art form. The possibilities are only limited by the human imagination. Stencil makers produce art that is expressionistic, impressionistic, situationist, surrealist, satirical and poetic. It is a medium that the artist can make entirely individual. What comes through are the ideas behind the art as well as the unique expression, draughtsmanship and style. Different artists respond to different inspirations, and an artwork can be interpreted in multiple ways by its audience. Some stencil ideas work emotionally, some conceptually; and some work equally on both levels.

Stencil art poses many questions. Who was the creator? When did the image appear? What is the concept behind it? It makes us reappraise our surroundings. It turns the street into a gallery but, unlike in a gallery, there is an engagement with the environment, which is the canvas as well as the artwork. The strength of stencil graffiti is its ability to captivate people – off guard – as part of their day-to-day experience.

Graffiti is also a uniquely criminalized art form and in some ways this also gives it an edge: the audience feels part of something which is both personal and subversive.

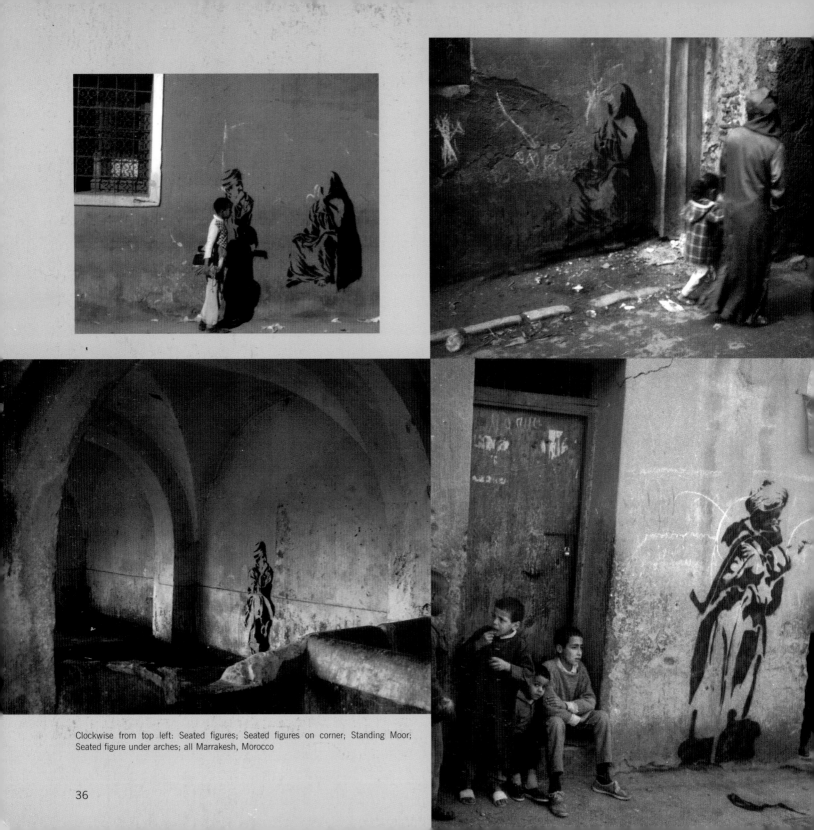

Clockwise from top left: Seated figures; Seated figures on corner; Standing Moor; Seated figure under arches; all Marrakesh, Morocco

36

BLEK

On a trip to New York in 1971 Blek saw art graffiti for the first time. Tags hastily finished with crowns, letters spray-painted with scrolls in the subway and colour generally pushed into every corner of the city. This etched itself in his memory but it was another ten years before he took it up himself. Meanwhile he studied architecture and engraving at the Ecole des Beaux-Arts in Paris: architecture made him realize the contrived nature of the city space, and engraving made him realize the creativity in illustration of the ancient master engravers.

A combination of ideas led to a flash of inspiration as Blek experimented and pioneered the use of stencils as a street art form in the early 1980s. One of his influences was the finely detailed poster wall art made by Ernest Pignon. But Blek's own work was soon to inspire a whole generation of stencil artists.

Blek describes his early excitement: 'I was alone in the city and the city belonged to me. After each night's work I would revisit the scene in daylight and sometimes spend hours at a time there, looking at my images and the people who passed them. Even the most furtive of glances at my work filled me with joy.'

Blek's earliest trademark stencils were of rats – which gave him the nickname 'le Rat'. As an image, rats were symbolic of urban decay and of an alternative street culture. They were life-sized and easily mistaken for the real thing. Blek's work progressed to life-sized human figures.

In 1984 he had the idea of stencilling an old man wearing a cap (see p. 8). This character was soon to wander through dozens of towns in France, leaving a trace of his own passing. He was known as Buster Keaton, Charlie Chaplin or The Old Man, and he soon became a phenomenon. When Blek began to find his creation gracing newspaper articles, he knew he was tasting success. He continued his work as an urban artist with a gallery of characters who were identifiable as his and with whom he in turn identified.

'There was Tom Waits, Andy Warhol, Marcel Dassault, a Russian soldier, President Mitterrand, Joseph Beuys, a faun, a prostitute, a running shouting man, several pregnant women, and others. About forty-odd characters in total. They are my creations and I resemble them all in some way or other.'

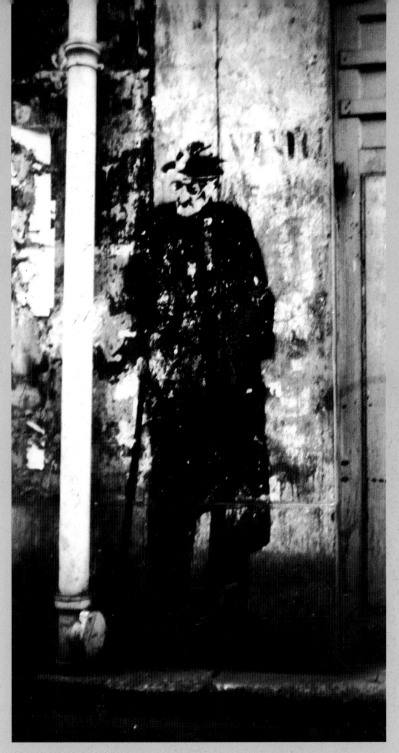

Above: Marcel Dassault, Paris

Far left: Faun, Château de Bagnac
Left: Russian soldier, Leipzig
Opposite: Butterfly-catcher by Némo, Paris

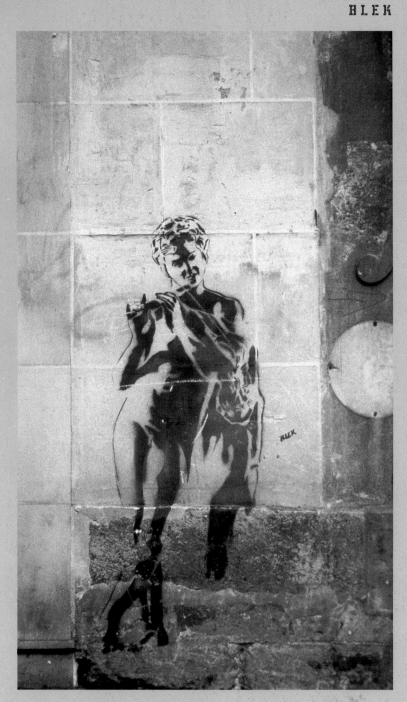

Blek placed these figures on street corners to create an element of surprise for the viewer. On turning a corner, the public would be fooled into thinking there was a real person there.

Blek's works are site specific. He draws inspiration from the locations he paints in; in Morocco, for example, he painted silhouettes of street traders, and in Paris mythological or classical figures with some local association or representation of the neighbourhood.

'They presented me to the world in the way that one person introduces another. I have always had the feeling of leaving something of myself behind on the walls of every city I've been able to visit.

'My intention was simply to speak out through imagery, to address the collective with a commentary on love and hate, life and death. It's a kind of therapy for me. I highlight the finer things in life by covering the walls with images that delight in distracting passers-by from their own concerns. Despite the police's underhand campaign to clamp down on graffiti, I continue to strike in dark streets because for me it's a vital part of the evolution of art. The scope for public paintings becomes more and more restricted as urban space is compartmentalized, and graffiti derives increasing meaning from its relationship to the surrounding architecture and social environment.

'And yet, despite the reduction in scale, the surface of any wall – whether stone, plaster, cement; dented, scratched, cracked, fissured – carries graffiti that transcends dimensions in all of its minute details. In this form it is like a painting hanging in a unique and extraordinary environment; and perhaps the galleries of the twenty-first century will engulf city dwellers, situated on the routes that they use for their daily business, and they will shun the temples to art reserved for the purpose.'

NÉMO
AND JÉRÔME MESNAGER

Sharing a studio in a converted cinema in Montreuil, Paris, Némo and Jérôme Mesnager are well-known international street artists who often collaborate together. They have continued to produce work since the beginning of the Parisian street art boom in the early 1980s. Their work is distinctly different but each compliments and interacts with the other.

Némo's art is often on a grand scale, making strong use of black silhouettes. His life-sized, bowler-hatted characters and supporting flowers, birds and hippopotamuses are part of a dream-like world that he has developed in response to his own children and to public arts projects with schools and the community. His pieces are site specific, designed to interact with natural and architectural features. He also experiments with other found surfaces in his gallery art, and has produced public works in cities around the world, including Bogota and Lisbon.

Jérôme Mesnager's work is not stencil art, though there are some echoes of the form in the way his drawn figures are broken into parts. His trademark white figure is freely painted, made by the artist posing against a wall and then quickly painting the remembered pose in a very gestural act. Mesnager uses this in a poetic way, sometimes combined with words and always reflecting the environment and location of the piece. In Burkina Faso his white figures reflected the lives of local people, with dancers and musicians painted on the adobe walls. Mesnager has also taken his work to walls in the USA, Morocco and India – even to the Great Wall of China. He enjoys a unique partnership with Némo, and his work illustrates comparative methods of creating street art.

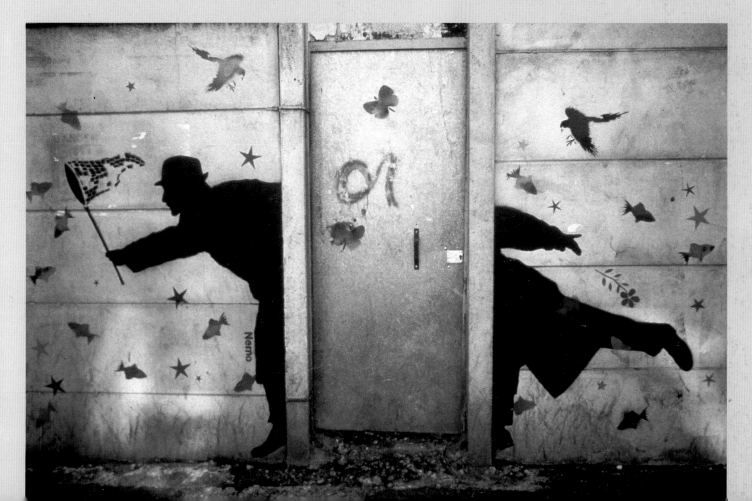

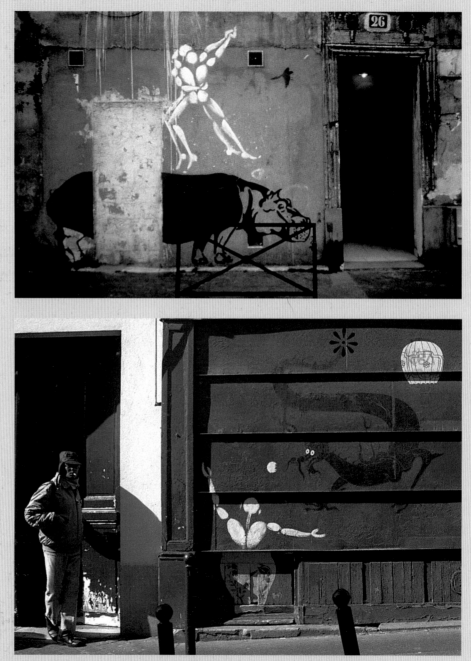

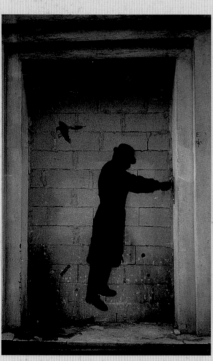

Clockwise from top left: Bowler-hatted figures by Némo; Dancing white figures by Jérôme Mesnager with Hippopotamus by Némo; Némo and Jérôme Mesnager's gallery, Rue de la Duée; Bowler-hatted figure in doorway by Némo; all Paris

Opposite: Figure with Tiger by Jérôme Mesnager, Paris

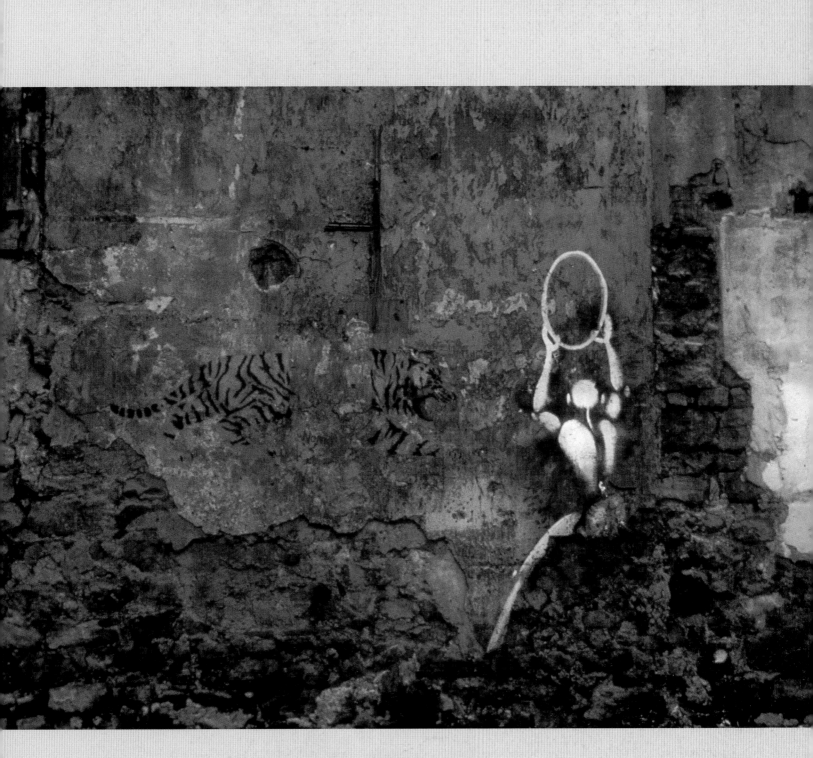

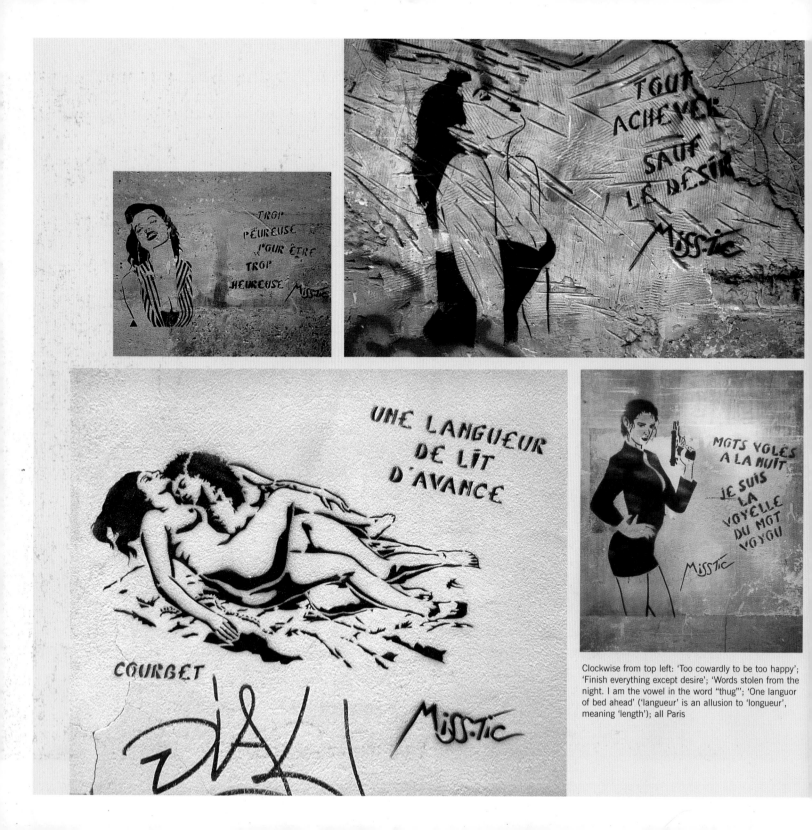

Clockwise from top left: 'Too cowardly to be too happy'; 'Finish everything except desire'; 'Words stolen from the night. I am the vowel in the word "thug"'; 'One languor of bed ahead' ('langueur' is an allusion to 'longueur', meaning 'length'); all Paris

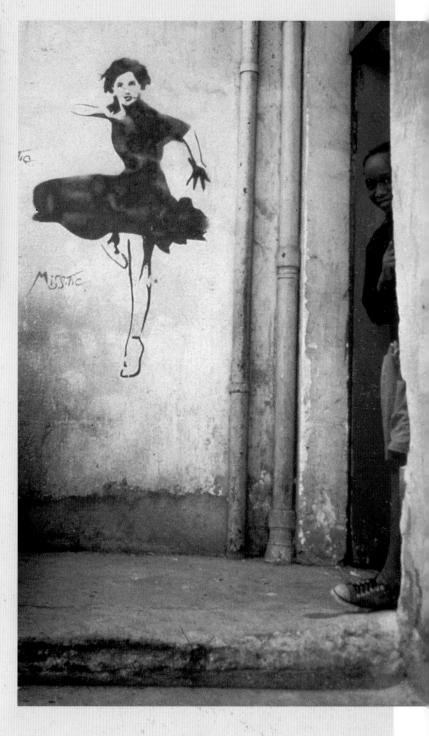

MISS-TIC

Miss-Tic's stencils have become legendary in Paris. She first began making stencilled street art there in the early 1980s. Her stencils are poems, and sometimes slogans, whose word-play works on many levels: 'Belle ou Rebelle' – 'Beautiful or Rebel'; 'A Ma Zone' – 'Amazon' or 'To My Zone'. Sometimes Miss-Tic asks questions: 'Les actes gratuits ont-ils un prix?' – 'Do free acts have a price?' The texts don't translate perfectly into English as they allude to nuances in the French language. However, their spirit does come across at the simplest level of translation and in the elegance of the stencil. Whatever the message, they are always recognizable. Although Miss-Tic's work is not intentionally political but rather personal and confessional, there are often underlying feminist themes in the pieces.

Miss-Tic's imagery often takes the form of stylized self-portraits but in 2000 she created a Paris-wide campaign of stencilled versions of famous paintings like Courbet's *Sleep*. Although she now exhibits regularly in galleries, she continues to work on the urban canvas by night.

This page, top left: 'I'd look hot on the streets of art history'; Centre: 'Amazon'/'To My Zone'; Right: Figure with girl; all Paris

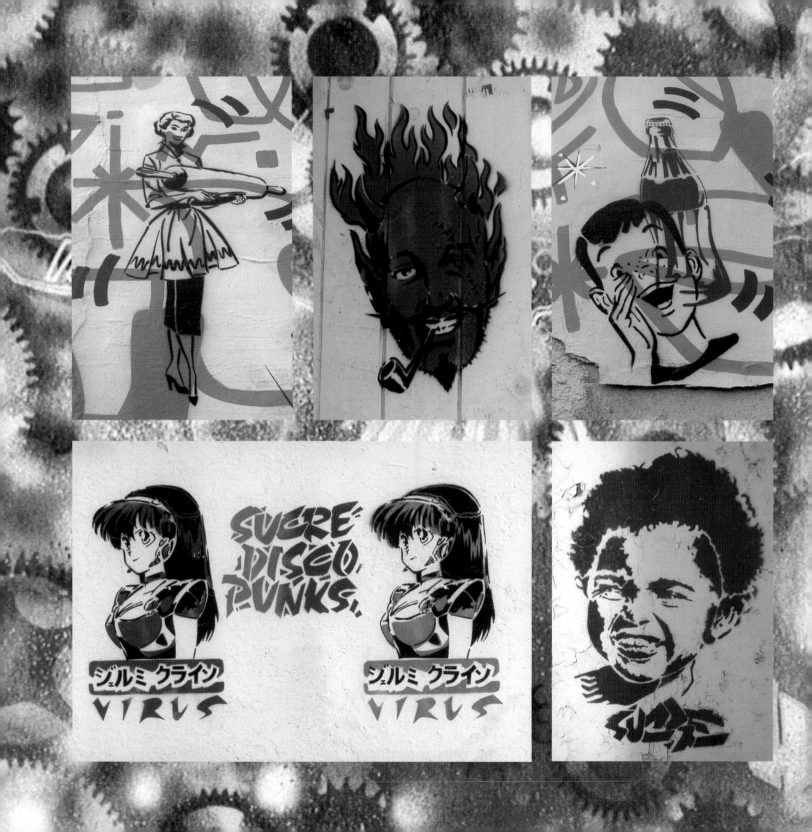

N Y L O N

Nylon is a UK artist who works in all forms of aerosol art, from walls to paintings on canvas. His first stencils were for punk band Crass in around 1981. During 1992 to 1993, he painted around 2000 stencils in Brighton, including a series of portraits of friends called 'Sucre Models'. He also experimented with sets of stencils that could be used in different compositions, the most acclaimed being a set of clock parts, mainly cogs.

Nylon's stencil work is strongly influenced by 1950s illustrations and outdated advertising slogans. Through these images, given a twist, the viewer can evaluate changes in society's attitudes towards consumerism and gender issues. (The name 'Nylon' is a reference to modern life.)

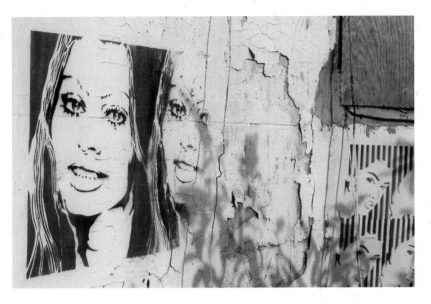

Opposite, clockwise from top left: Domestic Life – 50s style; Church of Bob – Devil; 50s-style advertising; Sucre Baby; Sucre Disco Punks; background, clock parts
This page, above: Sophia Loren and *Vogue* model; Below: 50s-style stencil collage

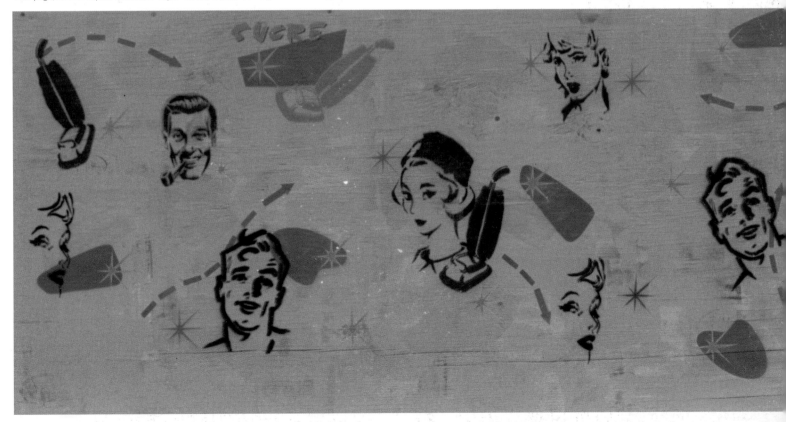

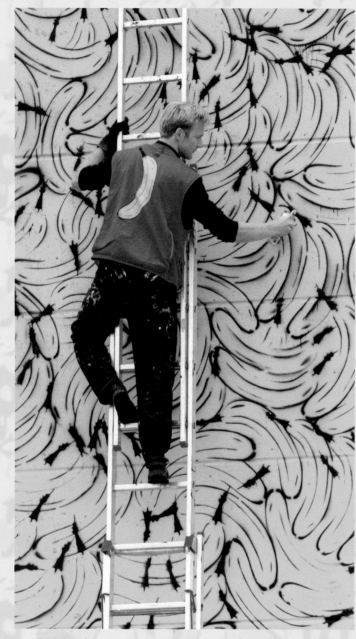

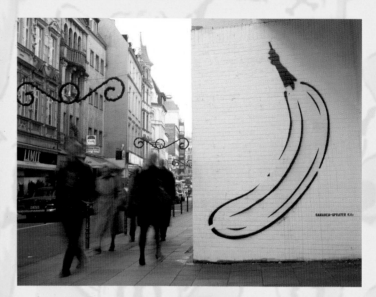

BANANENSPRAYER

For the German artist Thomas Baumgärtel, the banana stencil has taken the place of the paint-brush.

Baumgärtel sprayed his first banana in Cologne in 1986. The reception was rather cool. People took this symbol for a defacement of their doors and walls. Claims for damages rained in on him… Yet, within

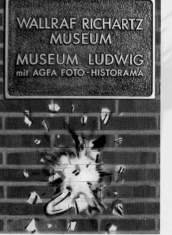
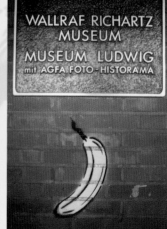

Above: Thomas Baumgärtel spraying the wall of a well-known German firm, Cologne
Above right: Ehrenstrasse, Cologne

Right: Spraybanana, Museum Ludwig, Cologne 2000
Far right: Spraybanana, Museum Ludwig, Cologne 1989

the Cologne art scene, there were other voices to be heard. More and more insiders began to speak up for him, defining the banana as a symbol of something positive.

Museum directors started to ask Baumgärtel to spray outside their galleries, identifying them as places for art. With the banana's Pop Art associations and its connotations of freshness, it posed an important question: what is the meaning of art today?

Baumgärtel's banana can now be found all over the world. However, it seems as if the artist has come to the end of his 'single banana phase'. Over the last fifteen years his imagery has been continually developing and changing. These days, whenever he has second thoughts about an institution or a gallery formerly graced with the banana, he simply 'confiscates' his image – by 'exploding' it (see opposite)!

Above: BSE – Banana, Neusserstrasse, Cologne
Right: Roof terrace, Cologne

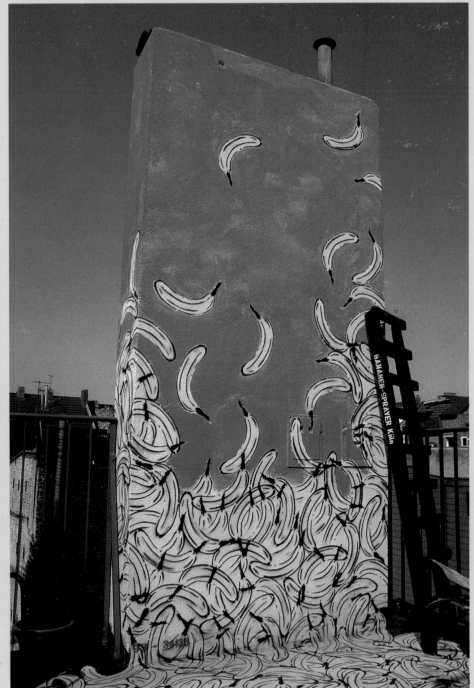

RUN FOR KOVA

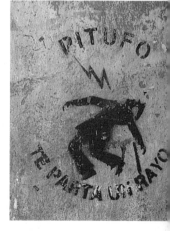

Top: Arab by Chou, Aachen
Above left to right: Slingshot, Paris; Whirlpool figure, Paris; Running figures by Bonehead, London; Electric Hazard, Barcelona
Opposite, clockwise from top left: Falling figure, Paris; Climbing figure, Barcelona; Figure on all fours, Bristol; Trashcan figure, Paris

FIGURES

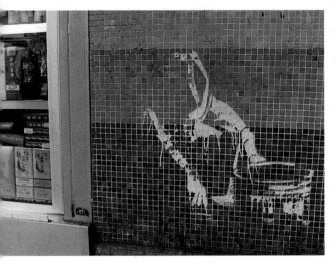

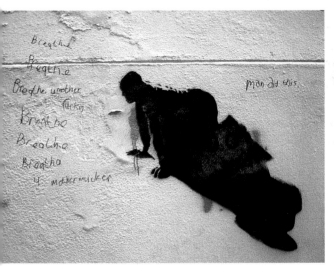

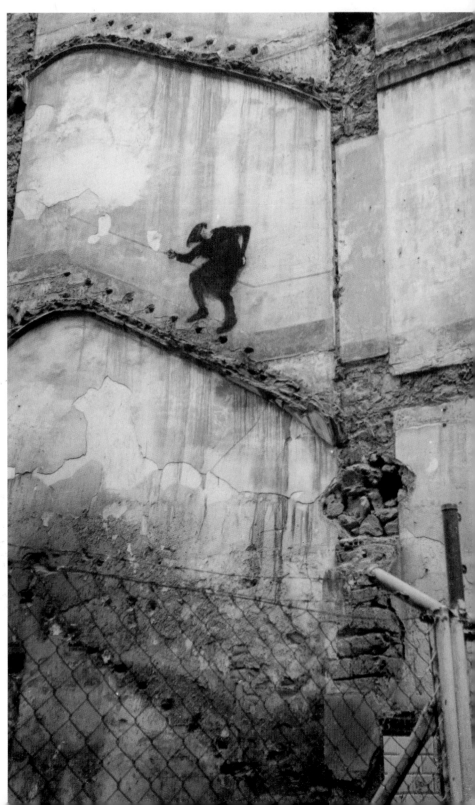

FACES

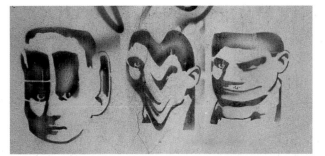

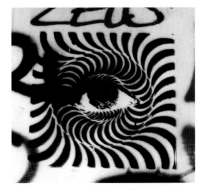

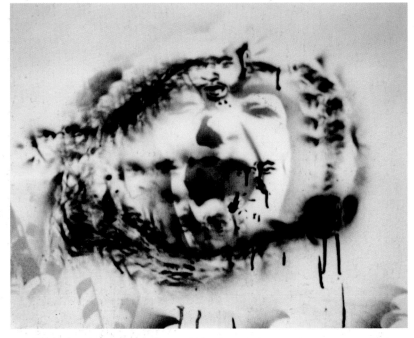

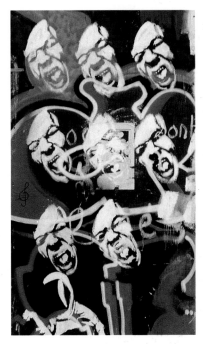

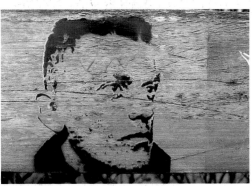

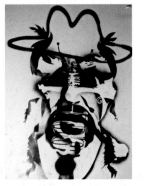

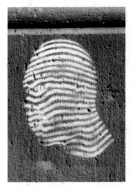

Opposite: Spiky-haired portrait, Bath

Clockwise from top left: Segmented face, Paris; Portrait on blue wood, London; Scream, Paris; Distorted Franz Kafkas, Prague; Boy's head, London; Lined head, Cologne; Portrait of Franz Kafka by Sniper, London; Portrait on park bench, Paris; Repeated Scream, Paris; Optical Art Eye, Paris; (centre) Video Nasty by Sniper, London

LIFE AND BIRTH

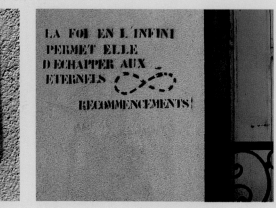

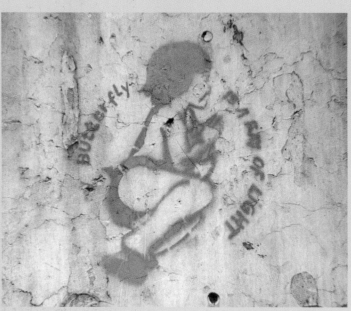

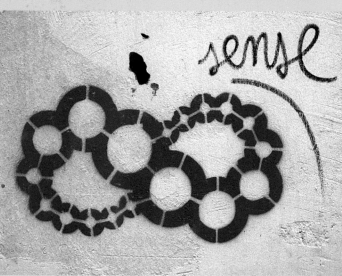

Clockwise from top left: Butterfly is a Ray of Light, Lisbon; Baby, Barcelona; Infinity symbol, Paris; Growing Oak by Bananensprayer, Cologne; Infinity symbol, Barcelona

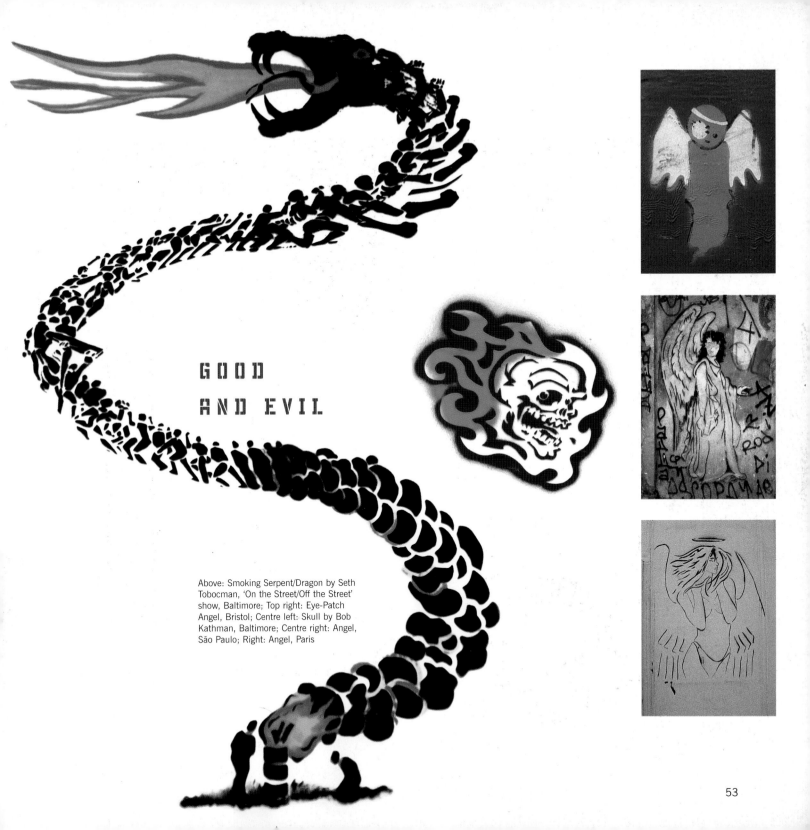

GOOD AND EVIL

Above: Smoking Serpent/Dragon by Seth Tobocman, 'On the Street/Off the Street' show, Baltimore; Top right: Eye-Patch Angel, Bristol; Centre left: Skull by Bob Kathman, Baltimore; Centre right: Angel, São Paulo; Right: Angel, Paris

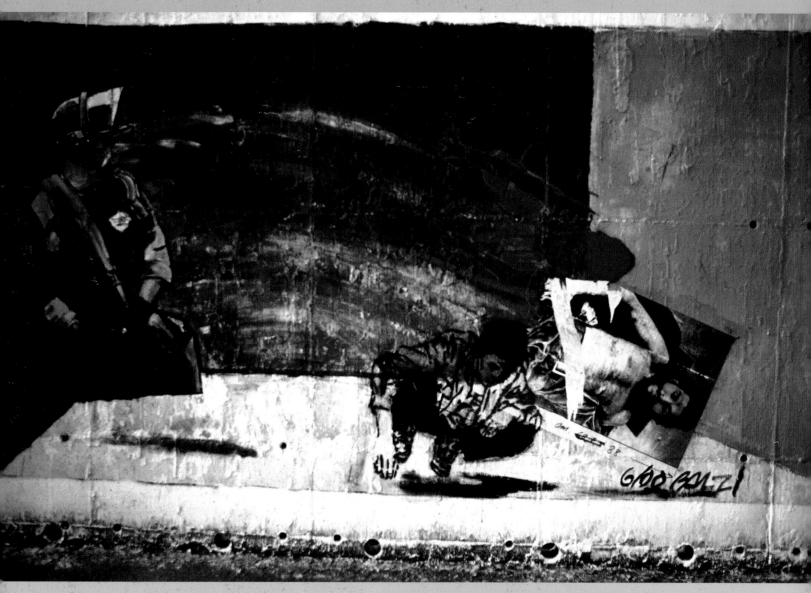

Above: Mixed media mural by Balzi, São Paulo Opposite, top left to right: Crowd, thought to represent Lech Walesa and the Solidarity Movement, Paris; Cocaine and Miss-Tic?
Mistake! by Xarrs, Paris; 'Hail Peace, Peace Salvation', Paris; Suicide/Gun to the Head, Paris; Bottom: Couple, Bristol

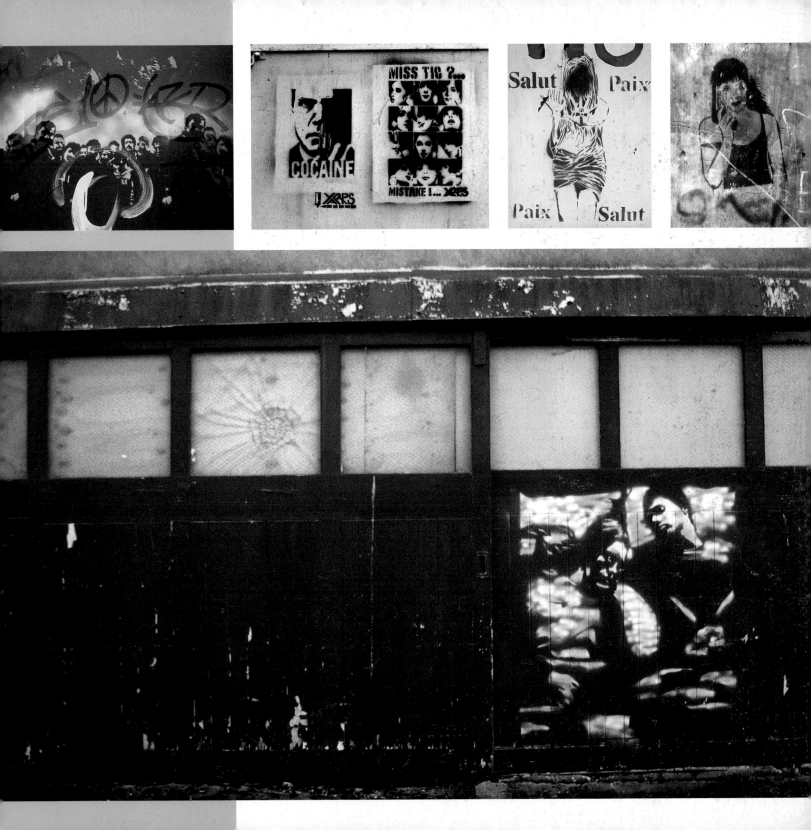

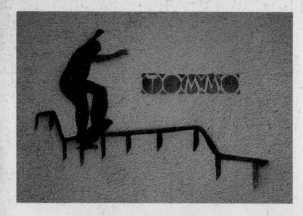

SKATES

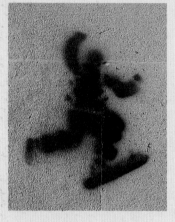

Top: Skating the Rails by Tommo, Bristol; Above: Skater, Bristol; Right: I Want to Skate Every Day, Brighton; Below right: Skating Skeleton, Barcelona

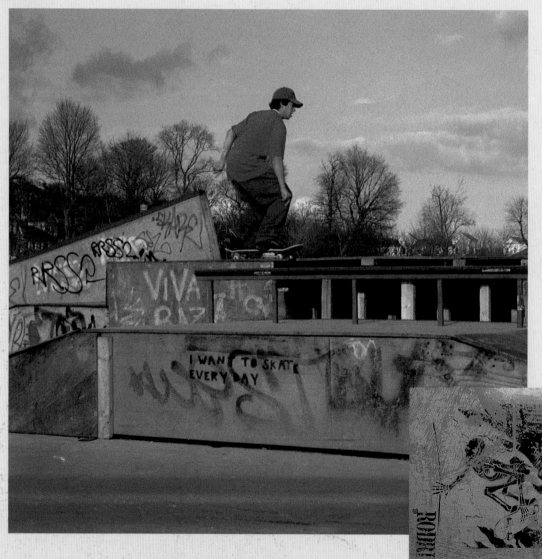

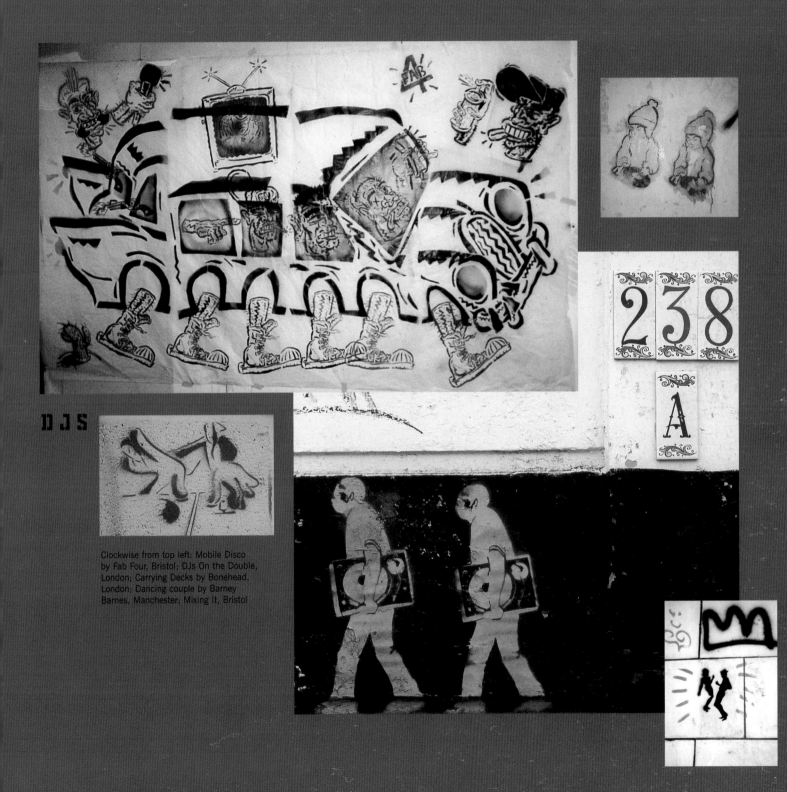

DJS

Clockwise from top left: Mobile Disco by Fab Four, Bristol; DJs On the Double, London; Carrying Decks by Bonehead, London; Dancing couple by Barney Barnes, Manchester; Mixing It, Bristol

COMICS

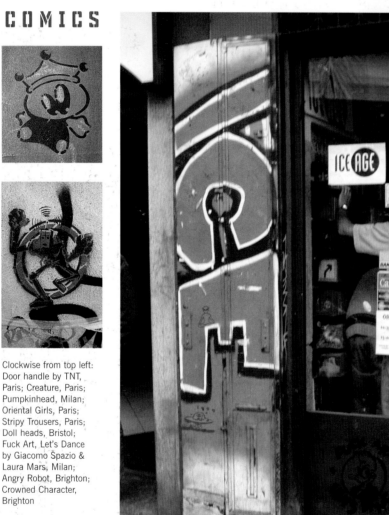

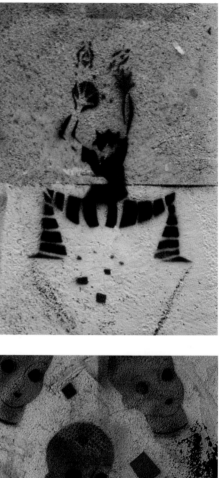

Clockwise from top left:
Door handle by TNT,
Paris; Creature, Paris;
Pumpkinhead, Milan;
Oriental Girls, Paris;
Stripy Trousers, Paris;
Doll heads, Bristol;
Fuck Art, Let's Dance
by Giacomo Spazio &
Laura Mars, Milan;
Angry Robot, Brighton;
Crowned Character,
Brighton

SOCCER

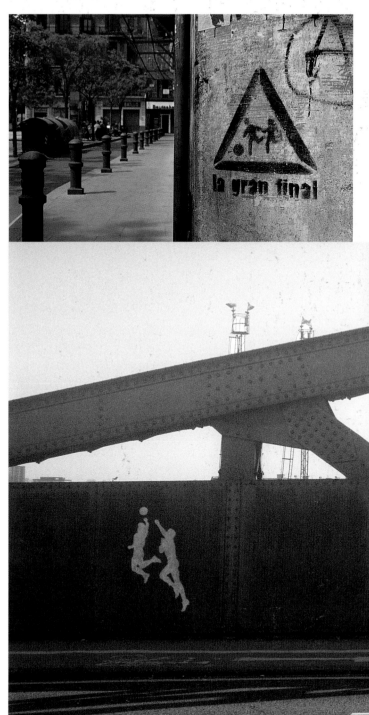

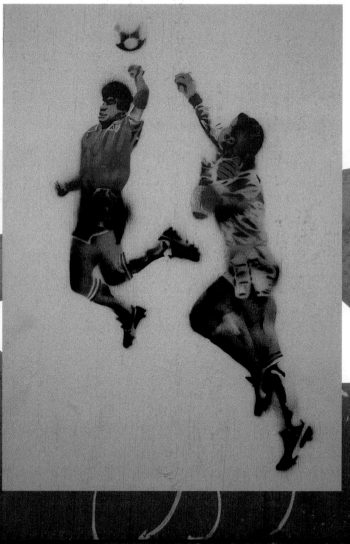

Left: La Gran Final, Barcelona; Below: Full-colour Hand of God (Diego Maradona's contested goal against England in the 1986 World Cup) by Jeff Row, Bristol; Bottom: Single-colour Hand of God by Jeff Row, Bristol

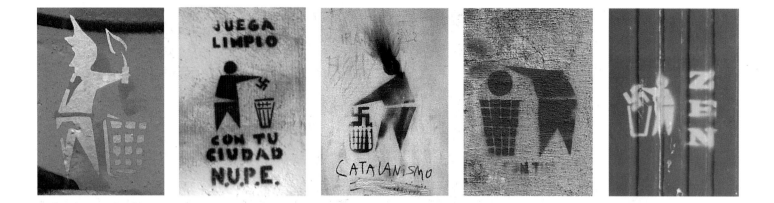

PROTEST

The motivation for stencil-makers is often a strong belief or message; for some it is a desire to make a statement of protest. Stencils are an effective medium for political graffiti, being easily reproduced and of a powerful graphic simplicity. They are an immediate commentary on current issues with the message literally and symbolically on the streets.

There are accounts of stencils put to political use as propaganda during the Second World War in Italy, and in post-war Germany they were used in an attempt to reunite refugee families. The technique was probably adopted from the military usage of the time.

During the political and social protest movements of the 1960s there was a proliferation of poster propaganda and poster art. Screen printing meant that mass print-runs were possible, and with art movements such as Pop, Op, Fluxus and Psychedelia flourishing, this was a period of great experimentation as well as social struggle. The 1960s poster art that developed out of protest movements such as the 1968 Paris student revolt influenced the imagery later found in political and issue-based stencils. The Situationist slogans of the May '68 riots – statements such as 'Under the paving stones, the beach!' – were graffitied freehand on the walls of Paris. This combination of social conscience and mischievous commentary has been a blueprint for many stencils today.

From around 1970 stencils were used in conflicts around the world, including Mexico, Nicaragua, Northern Ireland, South Africa and the Basque region, and they continue to be used now as a cheaper and more permanent alternative to posters. Artists' approaches vary from blunt and brutal to subtle and enigmatic. Protest art tends to make heavy use of symbols. Images like the waving flag, the gun and the clenched fist are used in many permutations, as symbols of empowerment and military force. These images have their roots in historical war paintings and early-twentieth-century revolutionary art – as in the work of the politicized Mexican muralists and the Russian revolutionary poster artists.

Another theme in protest stencilling is the iconic use of portraiture. Figureheads, especially in the twentieth century, have come to embody a cause or a national identity. Party leaders are portrayed as noble heroes through the dissemination of posters and other propaganda. If you compare, for example, the most famous portraits of Lenin, Stalin, Chairman Mao and Che Guevara, they are all depicted as visionaries, their eyes looking to the distance. These icons are used either to represent their own particular revolutionary ideals or their style is appropriated for new heroes and new struggles.

As can be seen in the graffiti campaign to free American prisoner Mumia Abu-Jamal, the walls of the world are, in effect, a free press, used to express solidarity for causes and issues both local and global.

Above left to right: Firestarter, Bristol; 'Play a Good Clean Game with your City, N.U.P.E', Barcelona; Catalanismo, Barcelona; Lose your Head by Sniper, Brighton; Anti-Nazi icon by Zen, Lisbon

Opposite, clockwise from top left: 'L'Art' (image adapted from Paris 1968 protest), Paris; Arrest by Orfes, Barcelona; Tank, Barcelona; Revolta, Barcelona

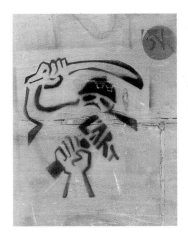

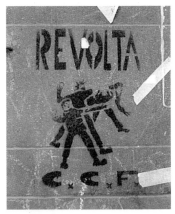

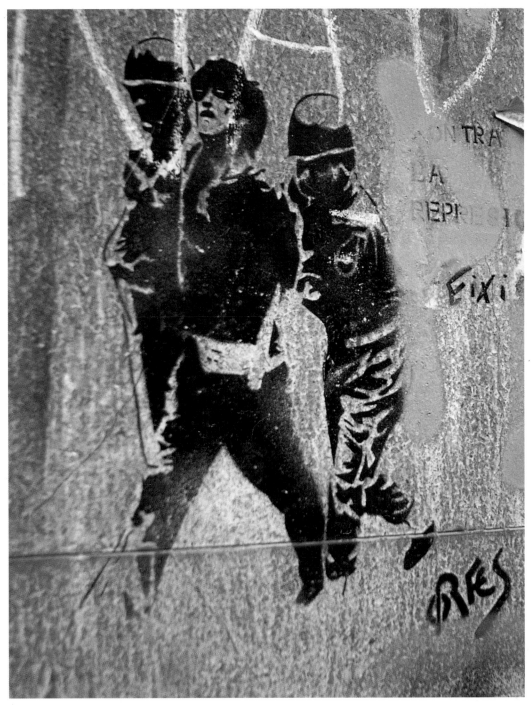

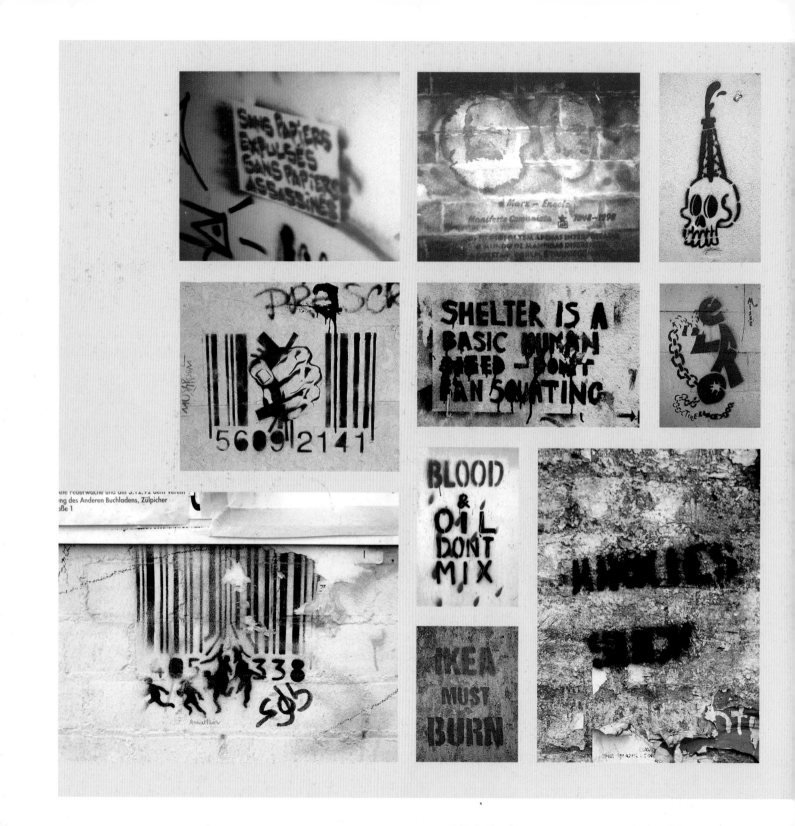

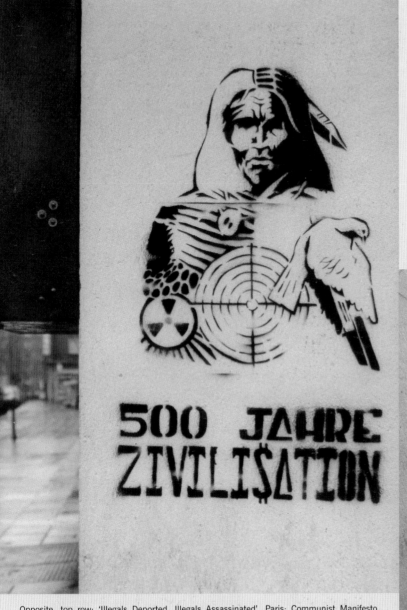

PROTEST

MULTINATIONALE CAPITALISME NON MERCI!

TOD

500 JAHRE ZIVILISATION

BONNE NUIT

Opposite, top row: 'Illegals Deported, Illegals Assassinated', Paris; Communist Manifesto, Lisbon; Oil and Skull (commentary on war with Iraq), Paris; 2nd row: Barcode Prison, Lisbon; Pro-squatting statement, London; Zero Tolerance by Misse, Bristol; bottom row: Barcode Escape, Cologne; (above) Blood & Oil (commentary on war with Iraq), Brighton; (below) Ikea Must Burn, Bristol; Junkies Suck, New York

This page, clockwise from top left: '500 Years of Civilization', Cologne; 'Multinational Capitalism, No Thanks!', Paris; 'Death' (anti-nuclear message), Cologne; 'Good Night', Paris

PROTEST

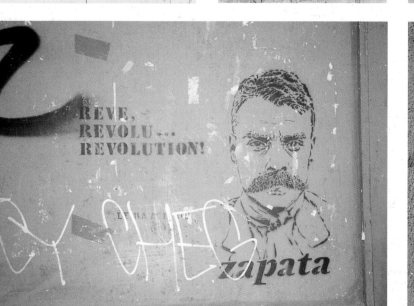

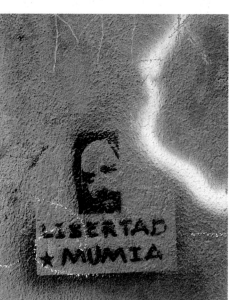

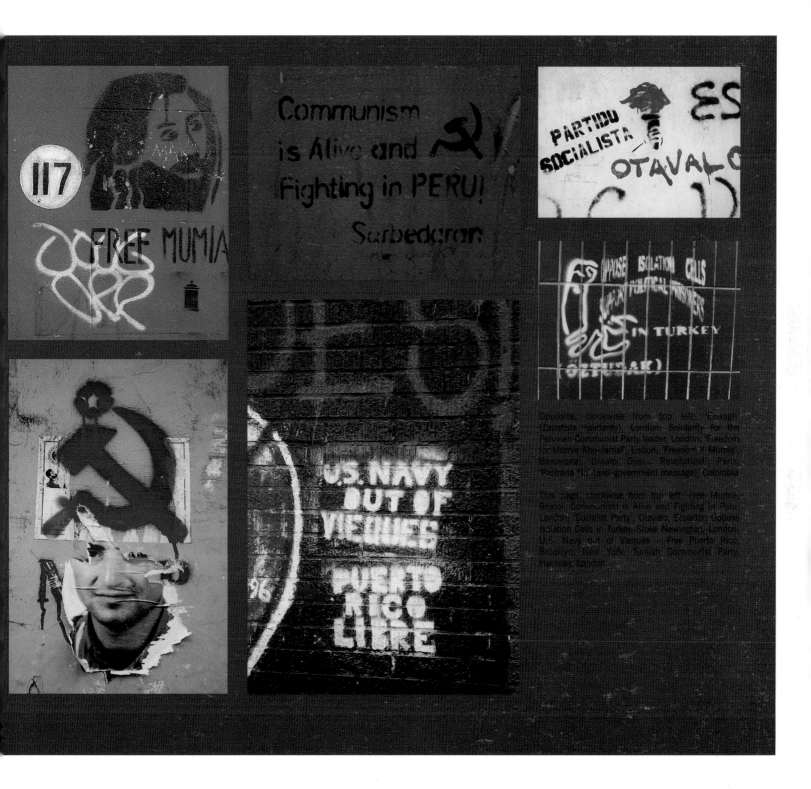

117

FREE MUMIA

Communism is Alive and Fighting in PERU! Sarbedaran

PARTIDO SOCIALISTA ES

OTAVALO

OPPOSE ISOLATION CELLS
FOR POLITICAL PRISONERS
IN TURKEY
(OZGURLUK)

U.S. NAVY OUT OF VIEQUES
PUERTO RICO LIBRE

Opposite, clockwise from top left: 'Enough' (Zapatista solidarity), London; Solidarity for the Peruvian Communist Party leader, London; 'Freedom for Mumia Abu-Jamal', Lisbon; 'Freedom = Mumia', Barcelona; 'Dream Over... Revolution!', Paris; 'Pastrana No' (anti-government message), Colombia

This page, clockwise from top left: Free Mumia, Bristol; Communism is Alive and Fighting in Peru, London; 'Socialist Party', Otavalo, Ecuador; Oppose Isolation Cells in Turkey, Stoke Newington, London; U.S. Navy out of Vieques — Free Puerto Rico, Brooklyn, New York; Turkish Communist Party, Hackney, London

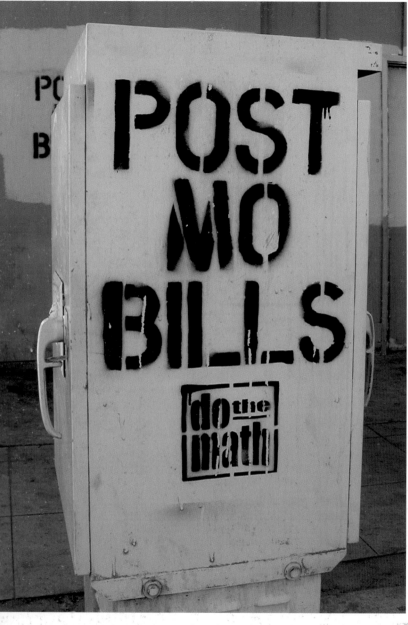

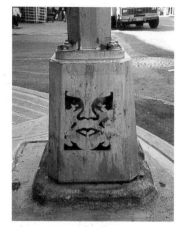

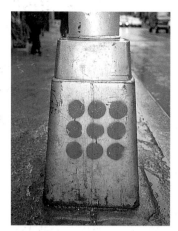

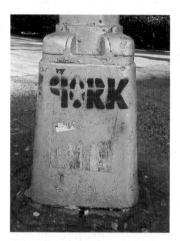

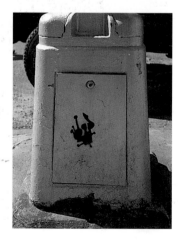

Above: Post Mo Bills by D.T.M. crew, California; Above right, top row: Spotted lamp post, New York; Obey Giant, lamp post, New York; 2nd row: Pork, lamp post, New York; Head, lamp post, New York; bottom row: Abstract shape, lamp post, New York; Spiky head, lamp post, New York

Opposite left: Obey fist by Shepard Fairey; Right: Roof-top stencil by Shepard Fairey

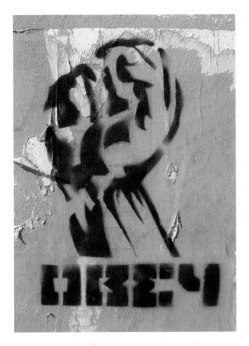

OBEY CAMPAIGN

Rhode Island design student Shepard Fairey first used the image of legendary Russian wrestler, Andre the Giant, in 1989. His original 'Andre the Giant Has a Posse' sticker poked fun at cliquey skate posses by creating an absurd fictitious gang headed by a 7'4" wrestler. The whole idea took off; stickers began to appear in cities across the US and Andre became a cult icon.

As the campaign became more of a comment on advertising, with a hint of Big Brother and a nod to the work of American artist Jenny Holzer, Fairey began to incorporate the word 'Obey' within the image. By creating a parodic brand with a slogan of obedience, his underlying message is that we should question our surroundings and corporate culture.

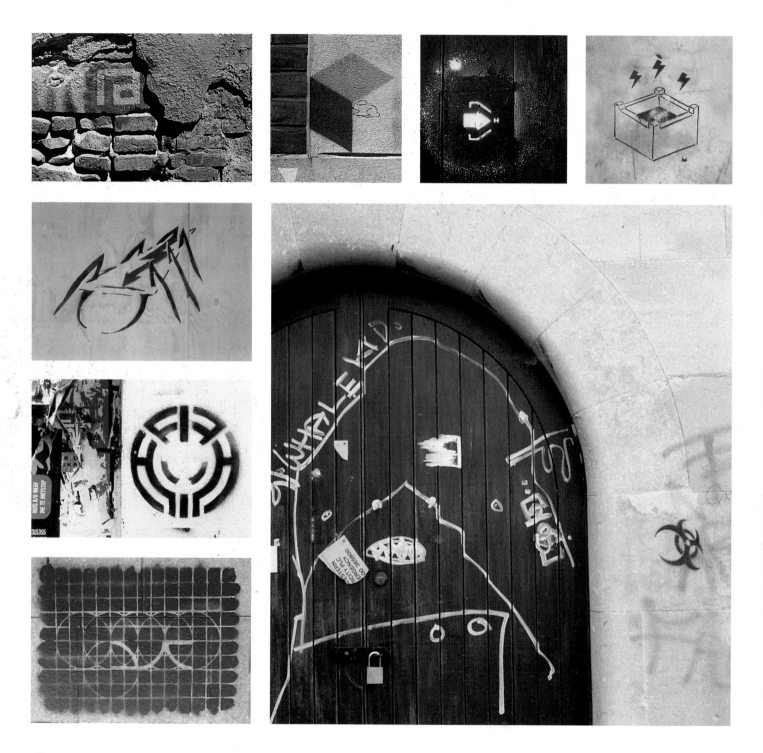

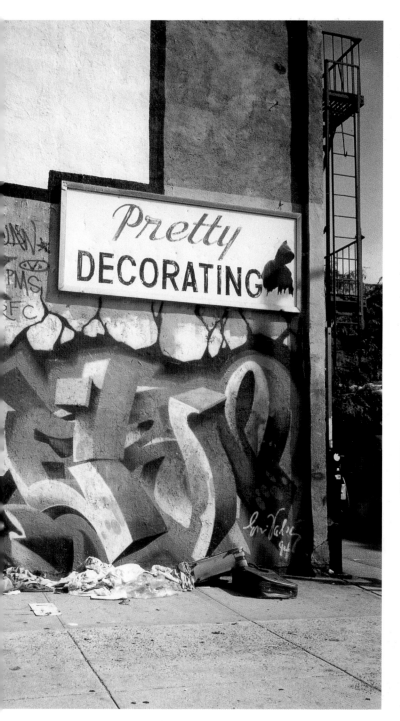

CODES

Many stencils are codified and make use of symbols. Some are recognizable, such as the @ sign; others are more personal and open to interpretation. New York street artist Dan Witz's code is the 'Hoody', which represents drug dealers in their hooded sweatshirt uniform. Witz installed 75 Hoody posters on the perimeters of drug-dealing areas. 'Besides the ominous "pause" given to passers-by, I intended the Hoody posters as warning signs, promoting awareness about a deepening problem in my own neighbourhood.' Although not strictly stencils, these images give the same effect, being screen-printed and cut so that the viewer is not aware of the paper.

Opposite, clockwise from top left:
@ symbol, Barcelona; Cube, Hoxton,
London; 'H' by David Hopkinson, Bristol;
Electric Fort, Oporto; Biological symbol,
Bath; Coded Soul, London; Territorial
sign by Clone, Rotterdam; Electric
scorpion, Bristol

Left and above: Hoodies by Dan Witz,
Lower East Side, New York

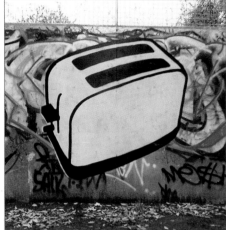

THE TOASTERS

The Toasters are a UK-based collective who, in January 1999, started an international campaign using the streamlined image of a toaster: 'an exercise in making something famous that essentially promotes nothing other than itself'.

The image has been placed on lamp posts, street signs, shop shutters and the like. 'To most,' say the Toasters, 'these are sites of public practicality. To us they are areas for potential urban intervention.'

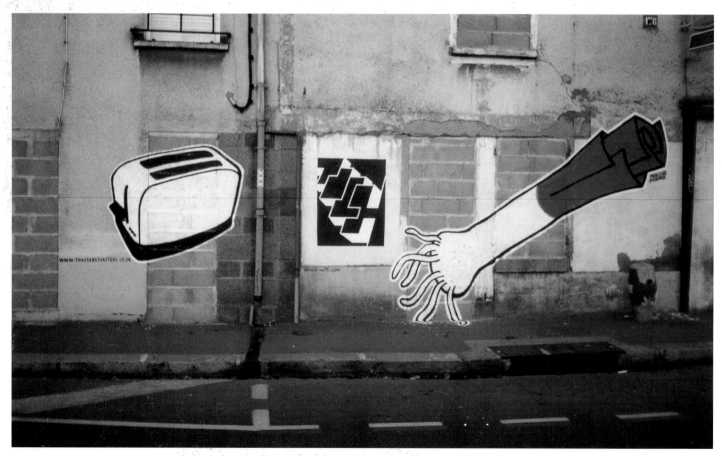

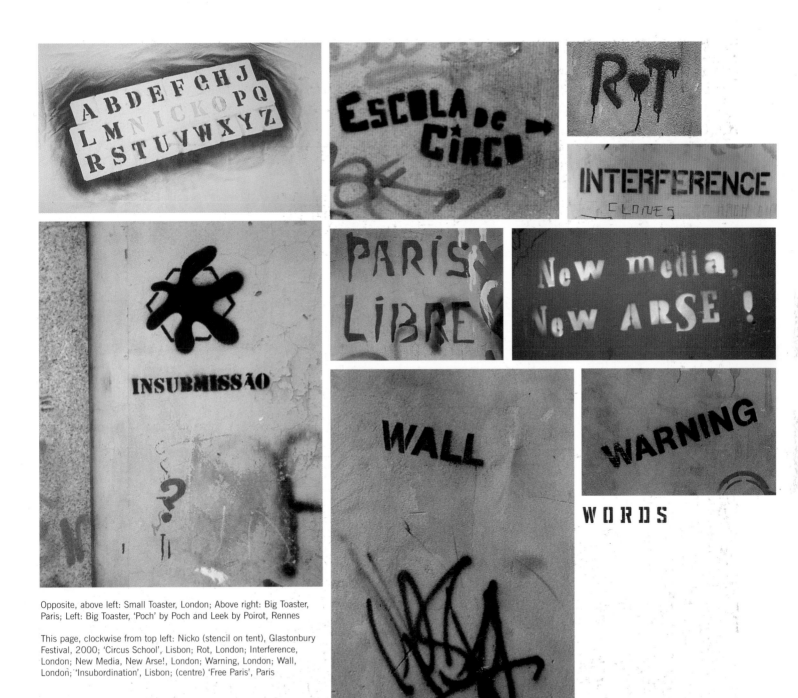

Opposite, above left: Small Toaster, London; Above right: Big Toaster, Paris; Left: Big Toaster, 'Poch' by Poch and Leek by Poirot, Rennes

This page, clockwise from top left: Nicko (stencil on tent), Glastonbury Festival, 2000; 'Circus School', Lisbon; Rot, London; Interference, London; New Media, New Arse!, London; Warning, London; Wall, London; 'Insubordination', Lisbon; (centre) 'Free Paris', Paris

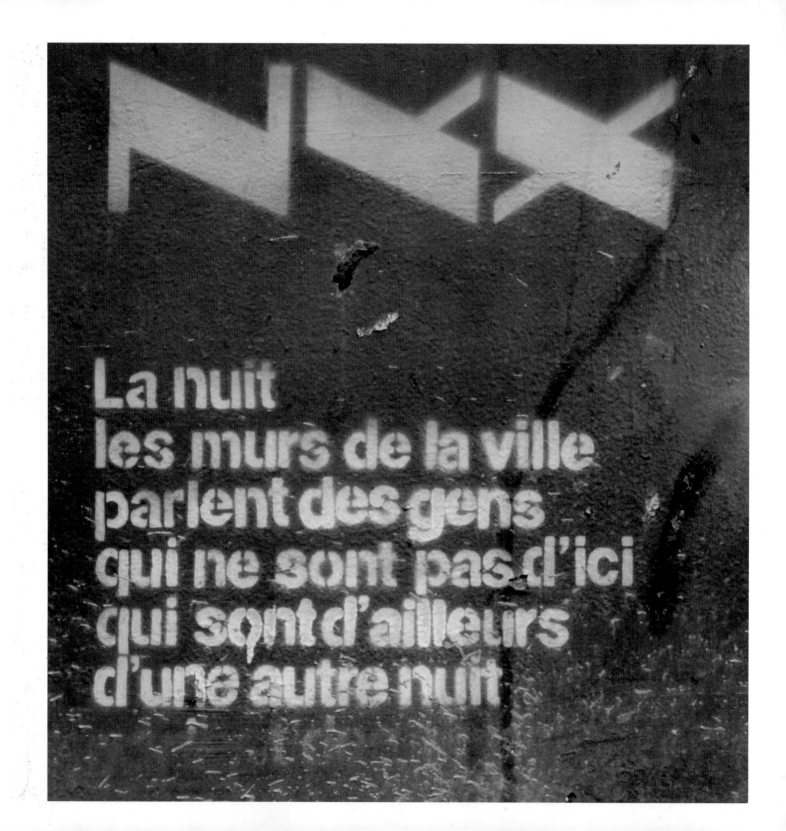

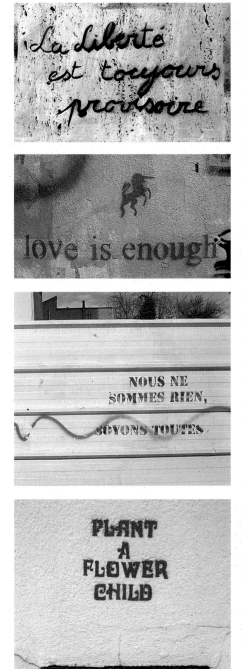

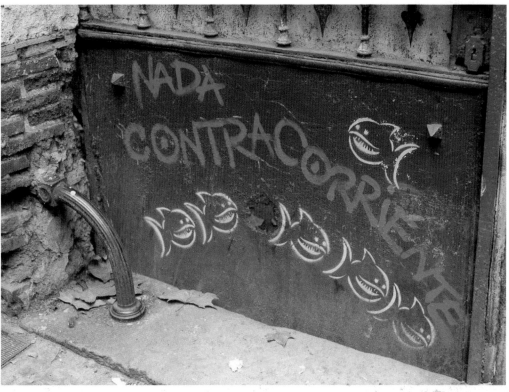

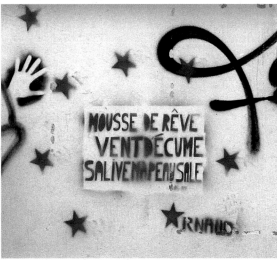

POETRY

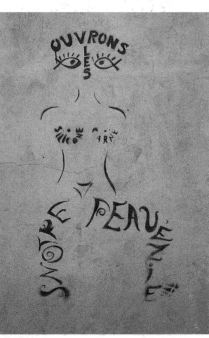

Opposite: 'Night falls, the walls of the city speak of people who are not from here, who are from elsewhere, from another night', Paris

This page, clockwise from top left: 'Freedom is always provisional', Paris; 'Swim against the current', Barcelona; Silicone Carne, Paris; 'Dream mousse foam wind drool on my dirty skin' by Arnaud, Paris; Plant a Flower Child, Brighton; 'We are nothing, let's be everything', Paris; Love is Enough by Nico, London

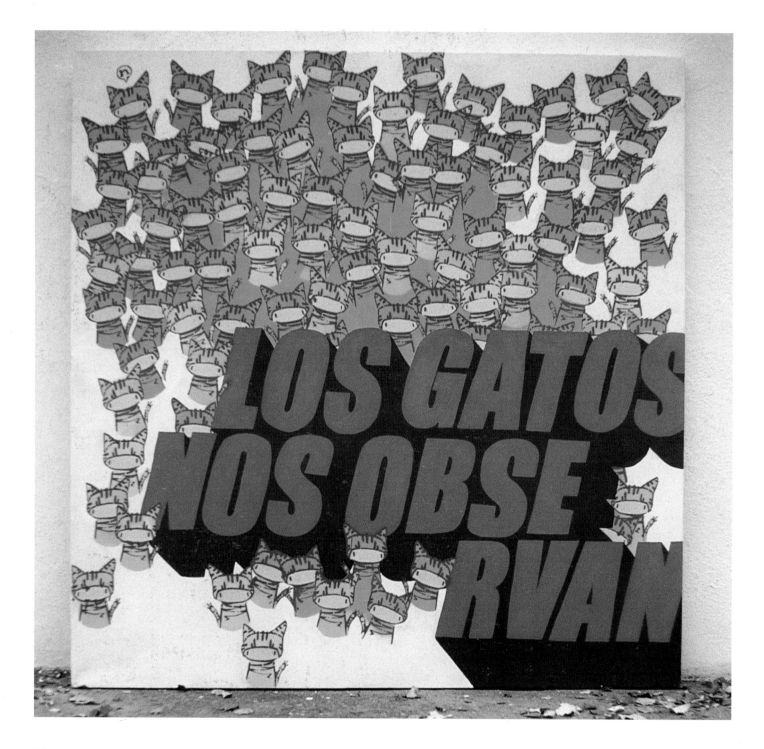

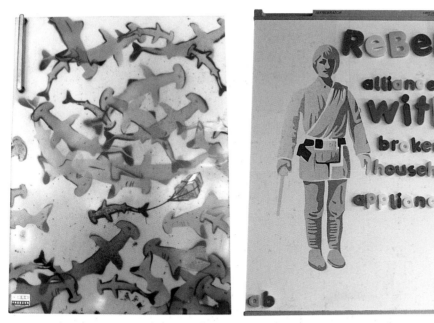

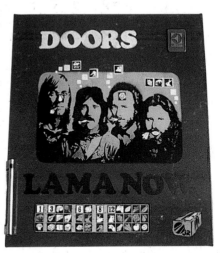

Far left: Hammerheads by Jeff Row; Left: Rebel Alliance by Andy Brown; Below: Doors Lama Now by Jeff Row (stencils on refrigerator doors at the 'D*frost' show); Bottom: Rhumba Girl by Bob Kathman (stencil on T-shirt at the 'On the Street/Off the Street' show)

ON←→OFF
THE STREET

Many contemporary graffiti artists are as active off the streets as on. The artists shown in this section also use stencils on T-shirts, record sleeves, envelopes and contents (mail art), canvases and skateboards; even on discarded refrigerator doors.

Galleries worldwide are increasingly recognizing street art and are working out ways in which to collaborate with the creators of an art form that usually exists outside of traditional institutions. 'On the Street/Off the Street', a stencil show held at Maryland Artplace, Baltimore, exhibited street-specific and otherwise 'anti-gallery' or 'non-gallery' work as a documentary of stencil activism and as a showcase of the graphic possibilities of the medium.

Street artists' roots lie in the bricks and mortar of the walls that they have sprayed, but they also know that there are other forums in which their work can reach out.

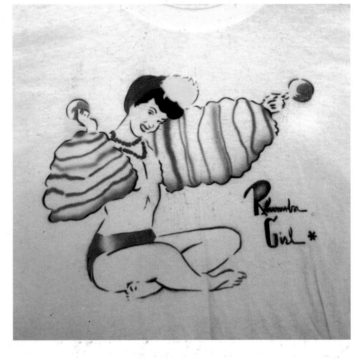

Opposite: 'The Cats are Watching Us' by Nano4814 (stencils on canvas)

BANKSY

Banksy was born in 1974 and raised in Bristol, England. The son of a photocopier engineer, he trained as a butcher but became involved in graffiti during the great Bristol aerosol boom of the late 1980s.

Banksy got his first break when he was asked to design flyers for a sound system after the printer went on holiday. In the years since then, he has refined a distinctive and iconic style which he has plastered all over walls, trains, bridges, cars, tunnels, books, records and even cows.

Banksy is most renowned for his strong sense of the ridiculous. Inside the elephant and penguin enclosures at London Zoo, he painted, 'I want out, this place is too cold; keeper smells; boring, boring, boring' in giant handwriting, which looked as if it had been written by the animals themselves.

In stencils, Banksy found the perfect medium, recognizing in them the potential for strong images and a quality of line with the strength to captivate an audience and twist their perceptions.

'I started off painting graffiti in the classic New York style you use when you listen to too much hip-hop as a kid,' he says, 'but I was never very good at it. As soon as I cut my first stencil, I could feel the power there. The ruthlessness and efficiency of it is perfect.

'I also like the political edge. All graffiti is low-level dissent but stencils have an extra history. They've been used to start revolutions and to stop wars. They look political just through the style. Even a picture of a rabbit

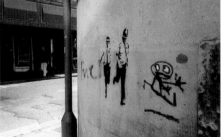

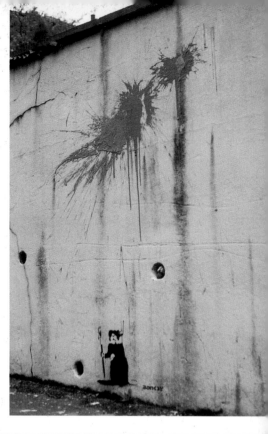

Clockwise from top right: Action Painting with Rodent; Street painting, Chiapas, Mexico; Central Police Station, Bristol; Tiger Economics, Manchester

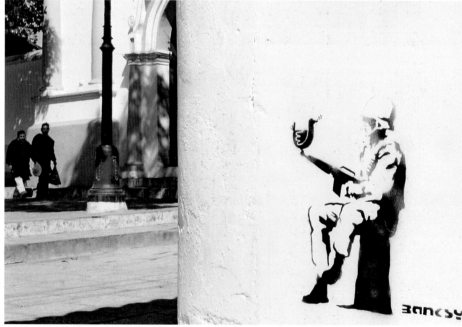

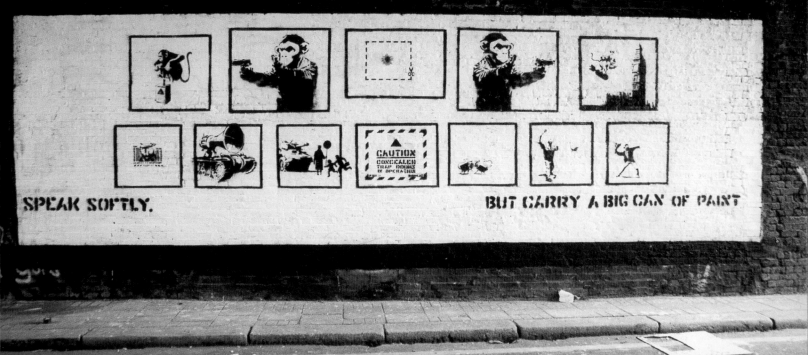

SPEAK SOFTLY.

BUT CARRY A BIG CAN OF PAINT

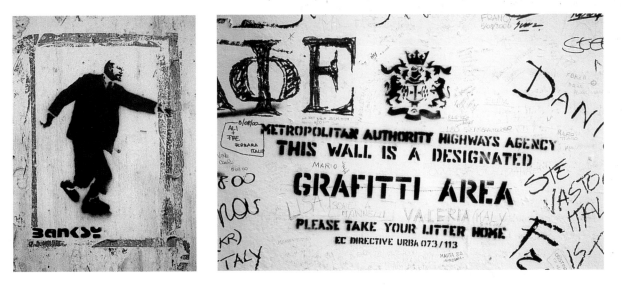

Above: Illicit street 'gallery', Rivington St, London
Far left: Who Put the Revolution on Ice?, London
Left: Alternative signage, London

Above: Exhibition at Glasgow Arches, 2001 Opposite below: 'Updated' oil painting from Portobello Market, London

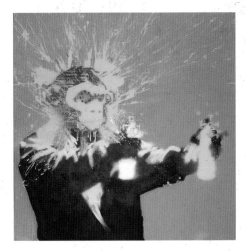

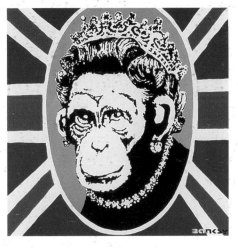

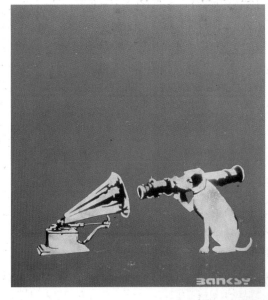

B A N K S Y

playing a piano looks hard as a stencil. It's like the charge of the light entertainment brigade.'

Banksy has painted stencils from London to New York. In January 2001 he travelled to the Zapatista-held autonomous zones in Chiapas, Mexico, as part of a tour in solidarity with the Zapatista movement. He painted a series of murals that depicted the struggle and he stencilled the walls of the town of San Cristóbal de las Casas with poetic images for peace.

'A lot of people think that scuttling around stencilling images onto buildings in the middle of the night is the action of a sad, frustrated individual who can't get attention or recognition any other way. They might be right, but I've done gallery shows and, if you've been hitting on people with all sorts of images in all sorts of places, they're a real step backwards. Painting the streets means becoming an actual part of the city. It's not a spectator sport.'

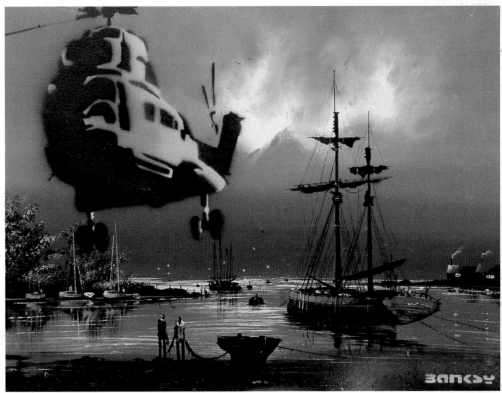

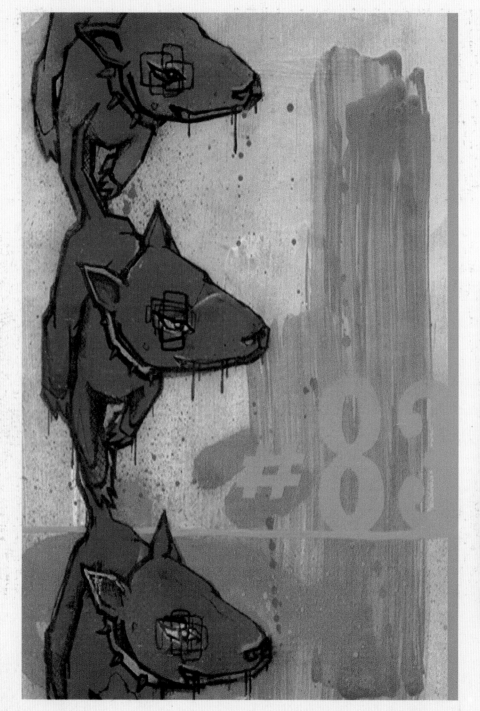

BONEHEAD

UK artist Bonehead uses many techniques in his street art, including stencilling and stickering, but one recurring subject is the bone – which he also uses as a pictographic tag. Bonehead works on canvas, too, and incorporates stencils, free-painted brush-strokes and spray-paint in a controlled energy that reflects some of the chance marks and compositions found on walls. The strong design and humour of his stencils always stand out, as do his unmistakable tags.

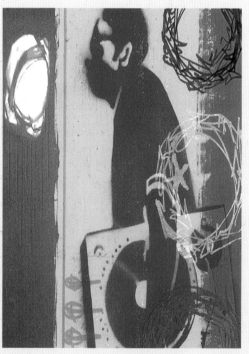

Left: Pitbull # 83 (stencils, aerosol and acrylic on card)
Above: Carrying Decks (stencils, aerosol and acrylic on card)
Opposite, clockwise from top left: Running Man with Suitcase, London; Bonehead tag and Bone Waiters, London; Man Carrying Decks, Heinz Phat Gloss and Toaster; Bruce Lee, London

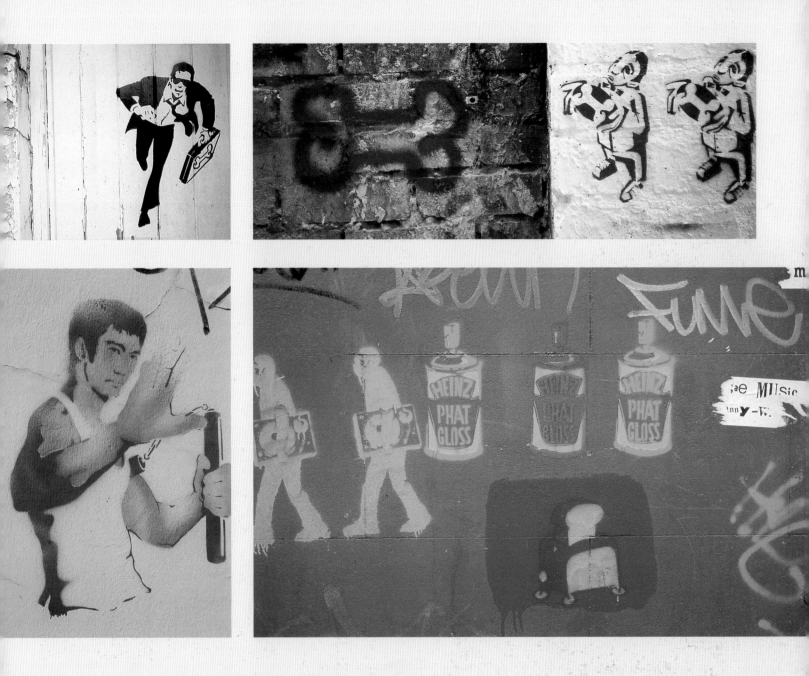

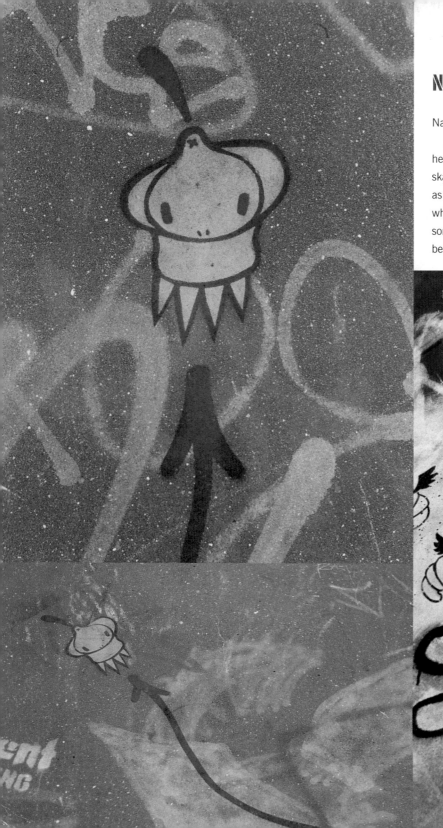

NANO4814

Nano4814 is from Vigo on the Atlantic coast of Spain.

'I chose the spray-can as my medium of expression in around 1995,' he says. 'I think it was a natural evolution after spending all day skateboarding in the streets – which I consider to be my main influence as an artist and as an individual. Seeing streetlife from on top of four wheels gives you another point of view of the city – you see it as something creative – and I think that makes you want to be part of it; to be in everybody's daily life, watching them from the walls.

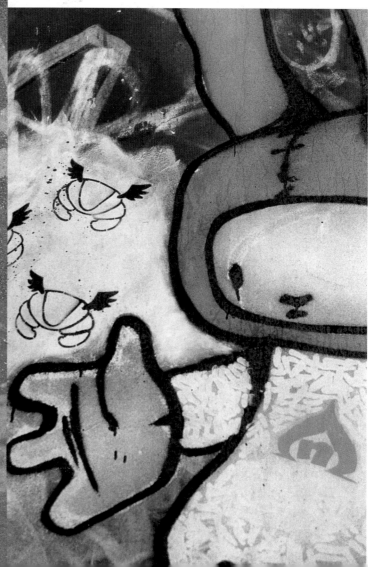

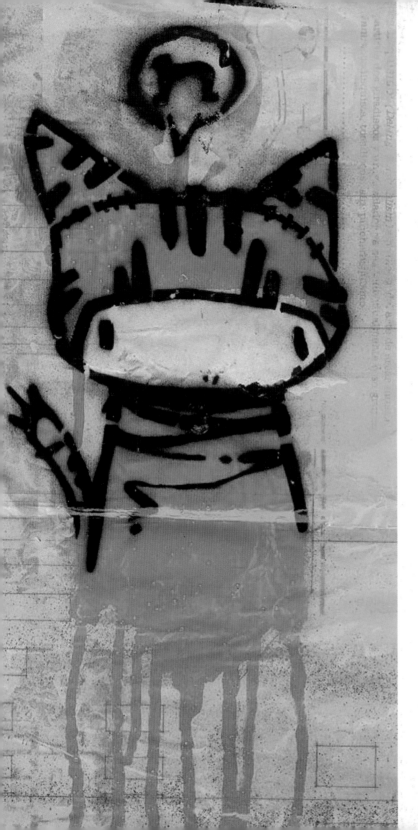

Opposite, clockwise from top left: El Choquito; Bunny Rabbit and Flying Croissants; El Choquito; all Brixton Skate Park, London

Far left: El Gato (The Cat; stencil on found paper); Left: El Gato (original stencil); Above: Nano4814 Flame Logo (stencil on paper)

'Another great influence on me was Dr Slump [a Japanese cartoon] and the crazy world it portrays, which gets really close to what I try to reflect in my work. Apart from that I get inspiration from music, everyday life or situations that make ideas pop into my head.

'My work evolves around my own world of characters, whether they be cats, rabbits, cows, kids or strange combinations of things. I always try to give the viewer something that won't leave them indifferent. Sarcasm and humour are important, and every one of my characters usually has some story behind them.

'"El Choquito" [The Squid] is my representation of myself and the medium I use – swimming in the streets, spreading the ink – and I use it most of the time I do something, as a signature.

'The first experiments I made with stencils were my own designs on my skateboards. After that I started to take them to the streets as an extension of my graff work. What I like about stencils is that you can repeat the same design over and over, and experiment with it in different contexts, either in the street or on anything you can find – old papers, canvas, advertising posters, tracing paper... Mixing techniques and keeping an open-minded approach to painting is really important for me to keep my mind working, trying to find the best way of transmitting the idea I have in my head.'

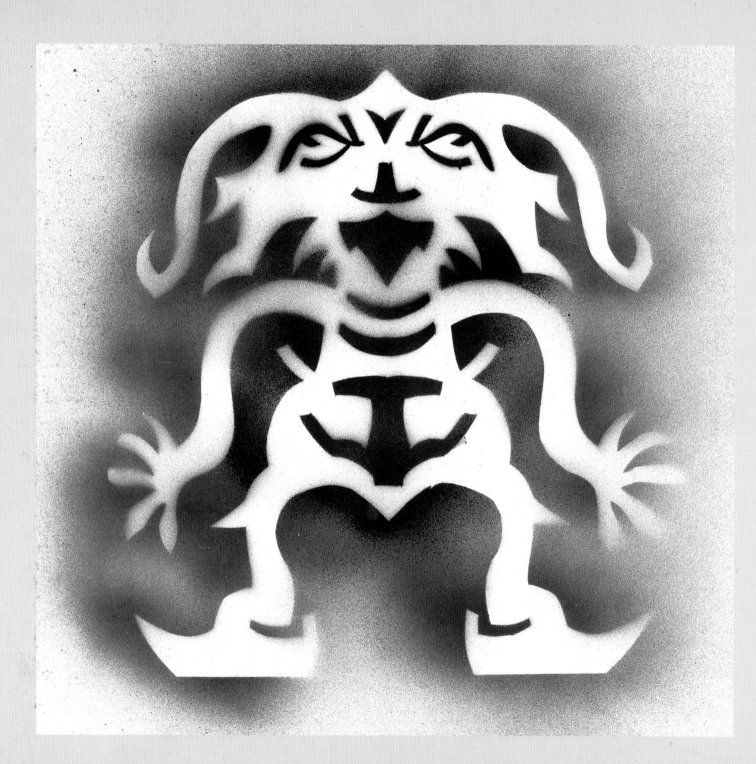

GERARDO YEPIZ

Gerardo Yepiz was born in 1970 in Ensenada, Mexico, and is now resident in San Diego. He started cutting stencils in 1980 with the idea of making a lightning bolt to spray-paint on a bicycle. Now, over twenty years later, his stencil art has branched out in many directions, including fine art, mail art and propaganda.

In around 1986, heavily influenced by the skate punk subculture, he began producing surrealist, fine-art stencil works with a pre-Hispanic influence. In 1995 he began to apply his work to skateboard ramps and T-shirts.

'Acamonchi' is Yepiz's alter ego for his propaganda projects. As Acamonchi, the artist produces stencils that celebrate and satirize Mexican popular culture by adapting images of well-known figures. These images made the headlines when they began to appear in Mexico City, having been downloaded from Yepiz's website – something the artist encourages.

Above: Mil Máscaras, Mexican wrestler (stencil on wood)
Right (above): Acamonchi postcard
Opposite: Pre-Hispanic-inspired figure (stencil on paper)

Above: Donaldo Colosio, assassinated Mexican presidential candidate, mutated into KFC's Colonel Sanders (stencil on wood)

Top and above: Flyer designs with stencil illustrations

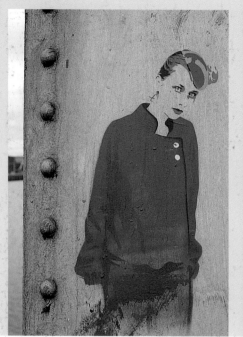

BERNIE REID AND PARIS

'I spent some time in Paris,' says Bernie Reid, 'wandering around the city, collecting references with my camera, and I discovered stencil art. The intricacy and style shown by artists such as Miss-Tic and Nice Art were a real eye-opener. I decided to try and bring a little spirit of the scene back to Edinburgh.' Reid's work has since appeared in fashion spreads for *i-D* and *Nova*.

British artist Paris studied fashion textiles and has applied his progressive, multi-layered aerosol techniques to many different textural surfaces. He uses various spray methods, including stencilling, with found objects from the warehouses of his home city of Hull.

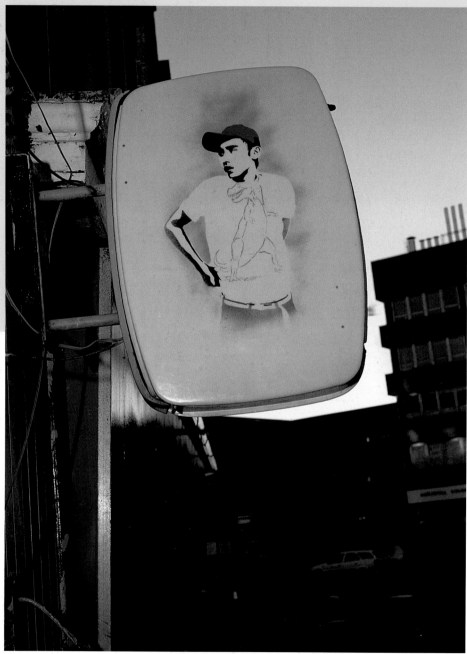

Above left: Stencil on metal girder by Bernie Reid; Above: Stencil on street sign by Bernie Reid (stencil fashion story for *Nova* magazine)

Clockwise from left: No Matter Where I Roam by Paris (study for textile design: collage on paper, incorporating stencils and other techniques); 3-D stencil on T-Shirt by Paris; Textile study by Paris (aerosol art on found paper)

87

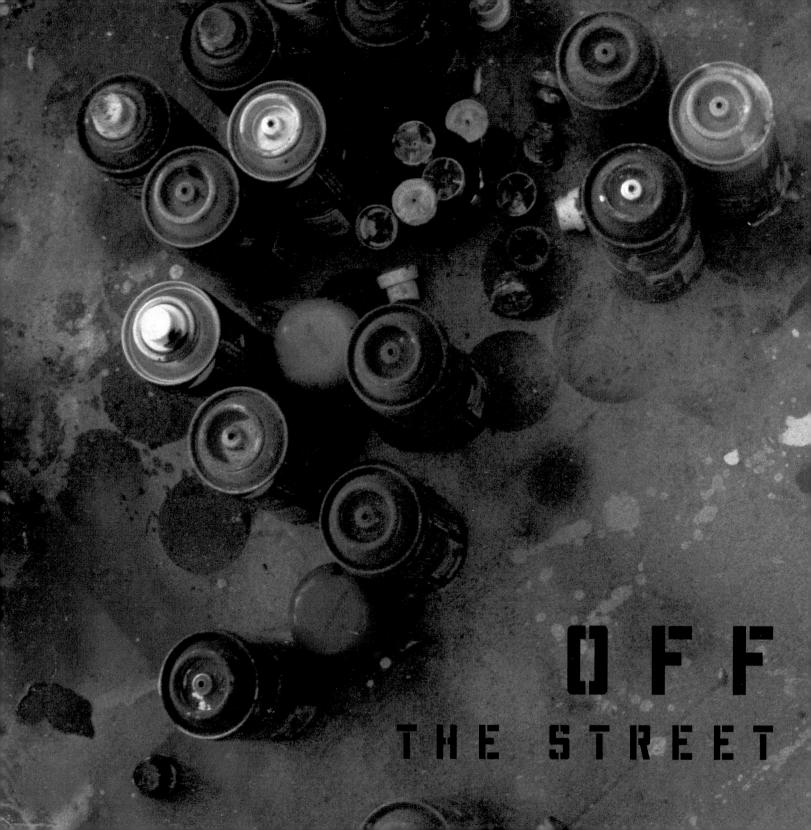

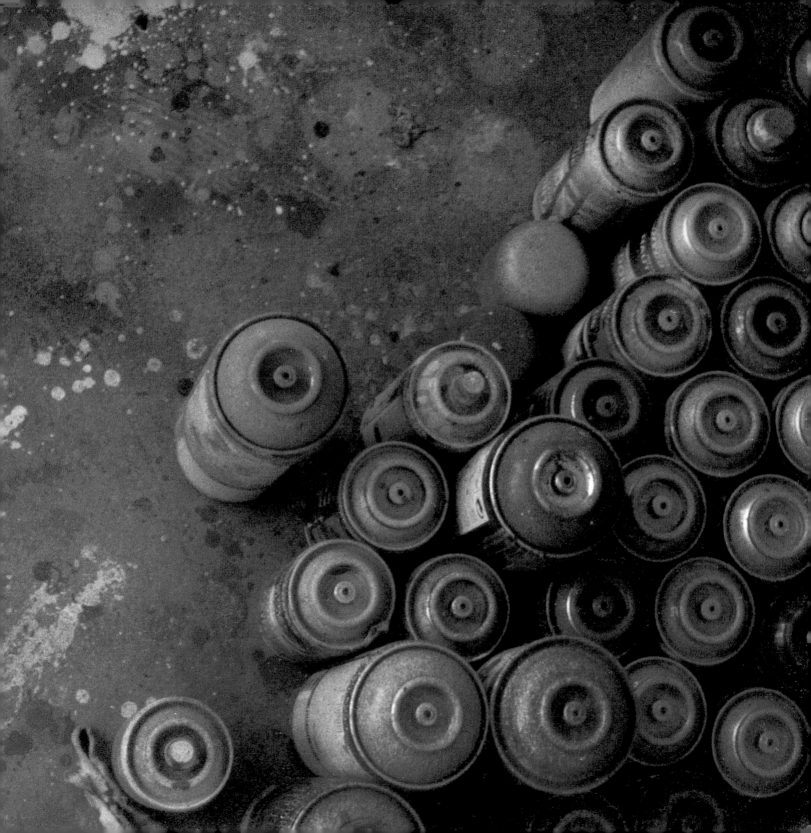

OFF
THE STREET

Indian shaking of the head

The confusion lies in
shaking of the head mea

What exactly is the problem? The confusion lies in a simple gesture. The characteristic Indian shaking of the head means *yes*; to the Western eye it looks like *No*. The action is not exactly shaking the head. It's as if the Indians have an extra bone in their necks which allows the head to glide in a sinuous back-and-forth-up-and-down-at-the-same-time movement, as smoothly as if it rested on ball-bearings.

A simple *unadorned* shaking of the head means *No*; nodding means a definite *Yes*. This other oscillation is multipurposeful; it

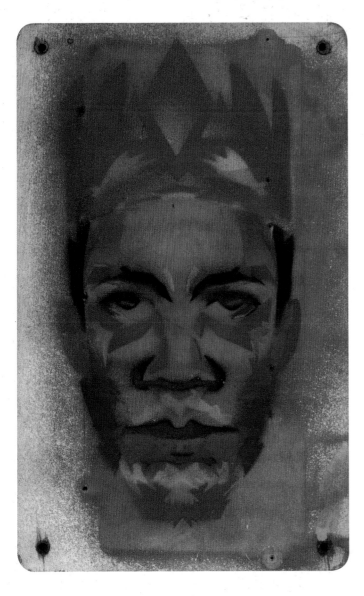

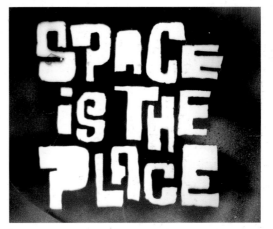

Previous pages: Nick Walker's studio floor
Above: Space is the Place by Swifty (stencil template)
Left: Portrait of King Tubby by Ian Wright (stencil on breadboard)
Opposite: Posture by Sunil Pawar (collage, stencils, aerosol on lithographic metal plate)

The process of stencilling is very flexible and these artists have exploited this by applying stencils to many customized and found surfaces such as wood, metal, paper, canvas and wallpaper.

Stencils can be applied along with other spray-paint or collage techniques, or they can be overlaid, distressed and destroyed until the desired effect is reached. Repeatability means that different colour combinations can be tried out. Stencils need not just be sprayed through but can be cut, drawn and hand-painted through. Other advantages are that work becomes more transportable and more readily used in commercial applications. There are many secret techniques and recipes that different artists make their own – motion-blurring, wet reverse printing and controlled dripping of spray-paint to name but a few. Approaches vary from rough to highly detailed and crisp.

However, many artists – particularly those who also work in the graphic arts and illustration fields – don't see themselves as graffiti artists at all and feel uncomfortable with the label and the expectations that come with it. They don't want their artwork to be limited by the political and artistic connotations of graffiti.

What connects all the artists, however, is innovation, originality and an appreciation of the medium.

Stencils are associated with street art and functional applications, and are therefore perhaps overlooked as a creative medium off the street. However, as can be seen in the work shown on these and the following pages, stencils can be used on an astonishing range of surfaces and in myriad different ways. All the work in this section – expressive, experimental and groundbreaking – has been created out of the street context.

SWIFTY AND IAN WRIGHT

Above: 'If Dolphins were Monkeys' by Ian Wright
(stencil illustration for Ian Brown CD sleeve);
Right: Installation for Amsterdam coffee shop
by Swifty (stencils applied with dayglow paint);
Below: Stencil template by Swifty

London-based graphic designer Swifty is well-known for his typographic innovations for groundbreaking magazines and record labels. He has always stayed ahead of the pack by creating his own typefaces. Stencils have long been a favourite form, along with woodblock type and other traditional hand-crafted fonts. Swifty has also adapted his designs for the computer and created some of the first postscript typefaces, which retain the roughness of his hand-cut and sprayed lettering. He continues to use stencils, both as a typographic and illustrative element and as a way of stepping away from the computer, to create something with more energy and unpredictability.

For UK illustrator Ian Wright, stencils are part of an ever-expanding repertoire of techniques and materials. He is particularly well-known for his portraiture, having produced countless illustrations for the music industry. His portrait of dub pioneer King Tubby (see p. 91) combines a love of reggae with stencils applied to a favourite surface material – a breadboard. One of Wright's trademark illustrative styles is his use of Rorschach blot-style symmetry, which works well with stencil cutting, as stencils can be sprayed both sides to get a reversed image.

'TING'

Opposite left: Nerves by Logan Hicks (stencil on metal)

LOGAN HICKS

Logan Hicks started using stencils after a move to California. Having left behind an entire screen-printing shop for the sunny skies of San Diego, and therefore without his usual means of producing art, Hicks turned instead to the cut stencil and a can of spray-paint to mimic the screen-printing process.

Hicks enjoys the challenge that the limitations of spray-paint stencils offer. The lack of minute detail, limited colour palette and blurry line quality all add to the overall feel of his work.

Hicks is a founding member of the fine arts press Workhorse Printing, which carries out print work for clients such as Blk/mrkt, Shepard Fairey, Dave Kinsey and other contemporary artists.

Above: Temple by Logan Hicks (stencil on metal)

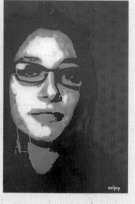

LOGAN HICKS

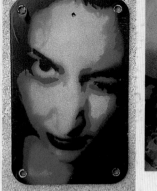

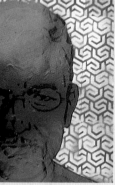

Clockwise from top left: Jenny;
Heather; Red Portrait; Evil Guy;
Blue Portrait; Deborah (stencil
portraits on metal)

SUNIL PAWAR

'I started painting at an early age. My work was inspired by the music from sound systems and pirate radio stations. Even now music is integral to what I do.

'I start my pieces by creating patterns using car sprays and emulsions to provide brilliant colour, spraying on old bits of lithographic metal plates, which I rescue from printers. They might still have abstract bits of imagery on them. I create stencils either on my computer or by using found objects. I also print text in reverse then photocopy images in black and white, and transfer them onto metal using paint stripper. I take stills as the process takes place and scan the stills into the computer. Using them as layers, I can construct and deconstruct the finished piece within a graphics programme, or I can turn the process into animation. The viewer can watch as the painting evolves. This also enables me to add music to the pieces, which gives an extra dimension to the work.'

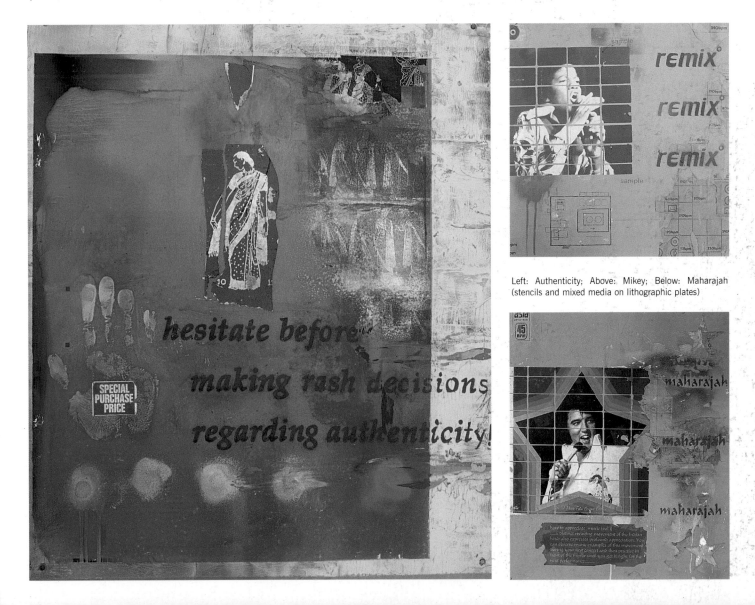

Left: Authenticity; Above: Mikey; Below: Maharajah (stencils and mixed media on lithographic plates)

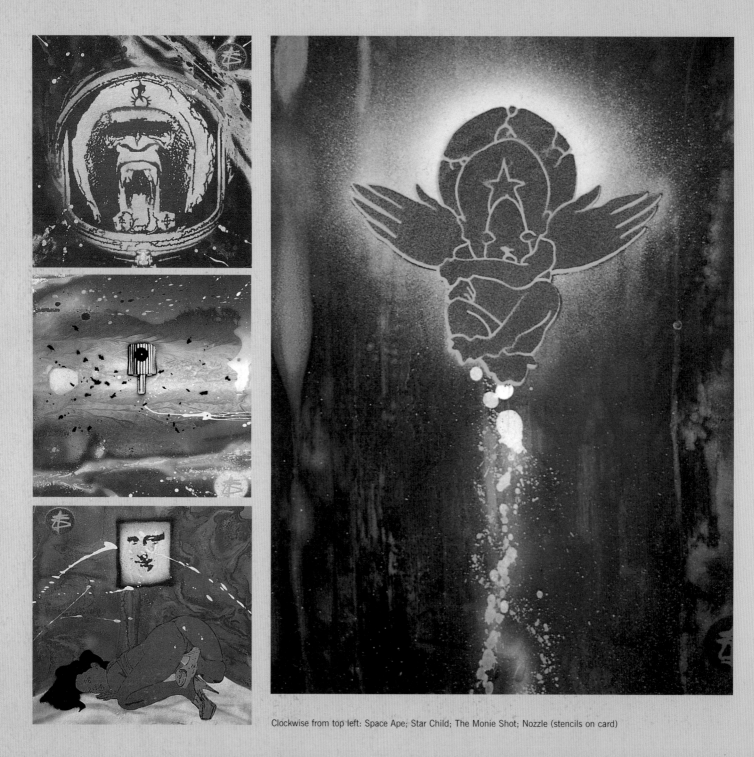

Clockwise from top left: Space Ape; Star Child; The Monie Shot; Nozzle (stencils on card)

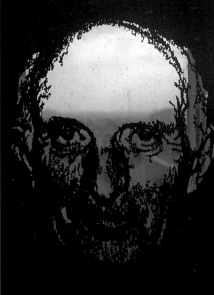

NICK WALKER

Nick Walker's work has moved on since the days when he sprayed walls at 4 a.m. to coincide with the shift changes of the Bristol police. These days he creates dream-like pieces on canvas, futuristic cityscapes and portraits in a combination of freehand painting and complex stencilling.

He has worked in the record, advertising and film industries, his credits including sleeves for Roni Size, images for Snapple and graffiti for the films *Judge Dredd* and Stanley Kubrick's *Eyes Wide Shut*.

'It's definitely a labour of love,' says Walker. 'Some of my more intricate stencils take days to cut.'

Left: Portrait of Carl Cox (stencil on canvas)
Above: Portrait (stencil template)

MITCH

Mitch is a prolific designer, based in London, who works mostly in music-related fields. Stencils continue to inspire him and he uses them as part of a bigger creative process for illustration and typography.

'I use stencils predominantly as a layering medium. They're like an instant screen print. They produce some great colour overlaps and rough offset edges. Also, the nature of spray-paint itself can provide some bad-ass colour fades/splats/cracks, etc.

'It's rare, though, that the stencil painting alone will constitute the final finished article. I'll normally take it through another process – or two – before I get what I'm looking for. This "multi-process" gives me the freedom to produce both futuristic and worn "old" styles of work very quickly.'

Mitch has also created a personal series of stencil fonts that typifies his retro-future style.

'Overall,' he says, 'the vital fact that my work must always have an organic overview dictates that I'll always need the stencil.'

Above: Illustration for Nike (stencils with Photoshop)
Below: Detail of portrait of Sun Ra (stencils with Photoshop)

Opposite left: Dirty Beatniks CD cover (stencils with Photoshop trickery); Right: Botchit Breaks Three CD artwork (stencil on card)

Top: Block (stencil font design); Above left: Fat Arse (stencil font design); Above right: Beatnik (stencil font design)

CHRISTOPHER BETTIG

Chris Bettig is a graduate of the Maryland Institute College of Art and has exhibited in Amsterdam, Baltimore, New York City, Philadelphia and San Diego. He has worked for several US museums, and is currently in the process of opening his own gallery in San Diego. His work can be seen on streets from Alaska to Iceland.

'Stencils work as an efficient repetitive tool,' he says, 'but they are also great in that there is a larger window for quick and easy change – for example, in line, texture and opacity. The final image depends on what type of paint is used – oil, acrylic or enamel; flat or gloss – and on the amount of paint – the saturation or light misting of the surface – or even whether paint is used at all. A multitude of variables can be manipulated in order to create many different looks. Combine this with other methods of "street" art and automatically it makes for interesting imagery.'

Above: There Are No Spies Here (brush-painted stencils and screen print); Above right: Jacques Yves Cousteau, Ambassador to the Undersea (stencils and screen print)

Opposite left: Assorted Space Invader stickers (stencil on stickers); Right: The New Japan (paper, acrylics and stencils)

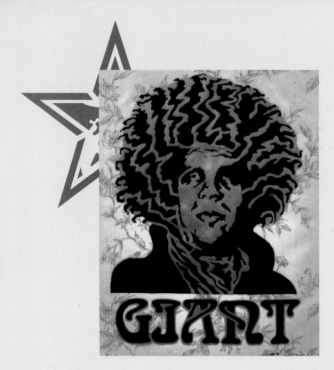

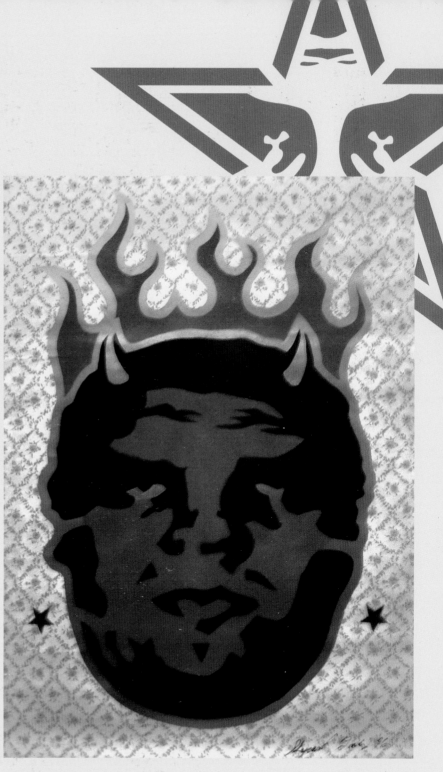

Above: Giant Hendrix (stencil on wallpaper); Right: Obey Devil (stencil on wallpaper); Below: Chinese Soldier (street stencil); background (this page and opposite), Obey Star

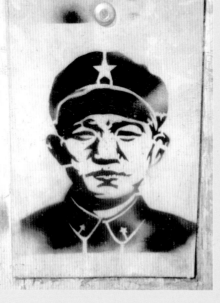

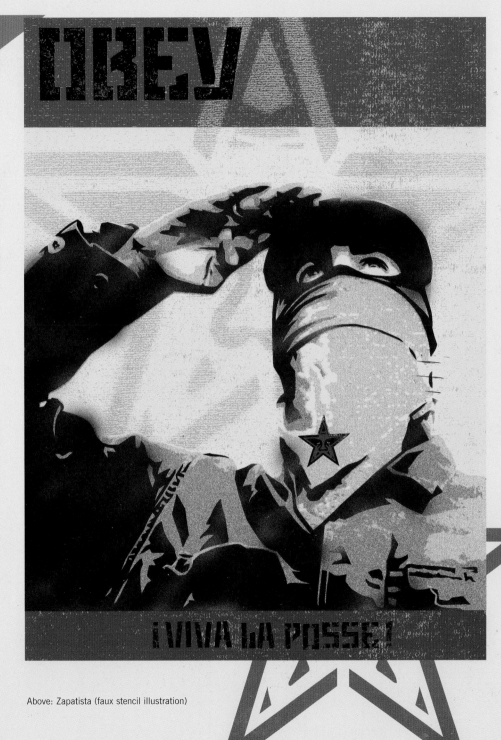

OBEV

¡VIVA LA POSSE!

Above: Zapatista (faux stencil illustration)

SHEPARD FAIREY

'I started skateboarding and listening to punk rock at the begining of 1984,' recounts Fairey. 'I had decided that the factory graphics on my board were too slick and I wanted to do something more punk. Sometime around then I made my very first stencil.'

Fairey was later to become well-known for his 'Andre the Giant has a Posse' campaign (see pp. 66–7). 'This began with stickers but grew to include stencils as a larger-format, more permanent way to spread the Giant imagery. One of the struggles with the campaign was balancing quantity and quality. Stencils were a great way to faithfully reproduce my art quickly while harmoniously integrating with the texture of the street.'

Fairey later used stencils to make posters on old wallpaper: 'a simple way to make hangable art for people who had seen my stuff on the street and wanted a piece'.

As demands on his time grew, Fairey needed help disseminating his work. Gerardo Yepiz (see pp. 84–5) helped make stencils of many of Fairey's designs, and also found a die cutter to mass- produce the two most used Giant icons.

'I am now able to send stencils with instructions to people around the world,' says Fairey. 'This serves a two-fold purpose: first, it spreads my work, and second, it teaches people a very simple method of reproducing their own. Beyond just having a charming aesthetic, the stencil is a cheap and effective way for an artist or activist to put their work in front of the public.'

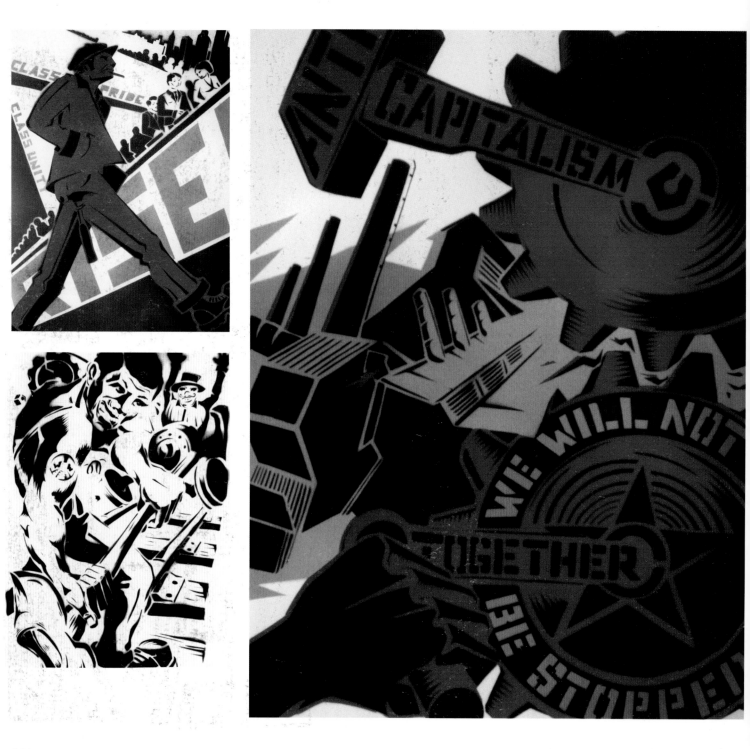

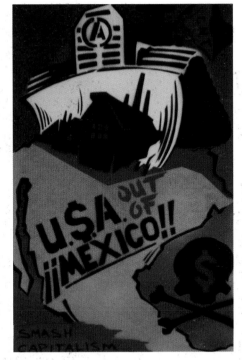

CHRIS FRANCIS

Chris 'Shortstop' Francis was studying at Maryland Institute College of Art when, fed up with the system, he hopped a passing train. He ended up riding the rails for several years.

Francis boycotted expensive art supply shops and instead bought his equipment at hardware stores. A utility knife, spray-paint, oil bars and found cardboard became his tools.

After returning to Baltimore, Francis went on to work with Logan Hicks (see pp. 93–4).

Opposite, clockwise from top left: Class Pride; Anti-Capitalism; Railroad Worker (stencils on paper)
This page, above: U.$.A. out of Mexico; Right: Jumping the Rails (stencils on paper)

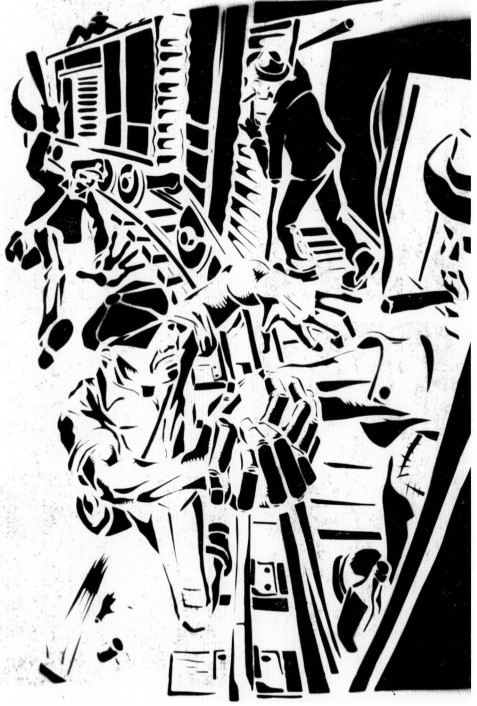

DAVE KINSEY

San Diego artist Dave Kinsey uses posters, stickers and stencils to create his street art campaigns, which have made their mark across metropolitan California.

His stylized figures are juxtaposed with single word messages, such as 'Rethink' and 'Unlearn', urging the onlooker to take notice and perhaps re-evaluate their own perceptions.

Street art activism and messaging is central to Kinsey's artistic philosophy but his output is not restricted to street works. He has taken his artwork onto canvas, wood, skateboard designs and record sleeves. His canvases share the same boldness and techniques as his work on the urban landscape, utilizing methods such as stencilling and spray-painting. The compositions are also inspired by the over-laying found on street surfaces – unfinished brush-marks, stencilled letters and dripping paint. The figures in his paintings are urban characters that seem to populate their own futuristic city.

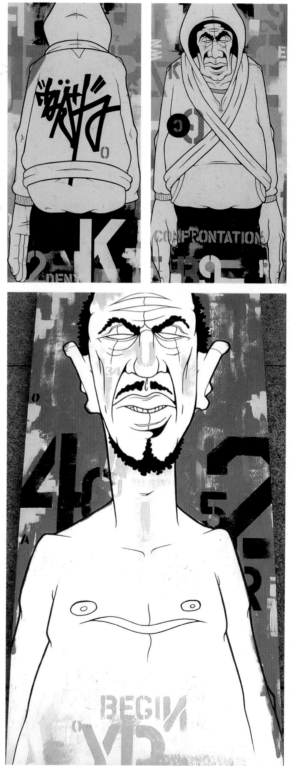

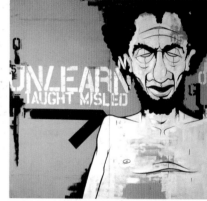

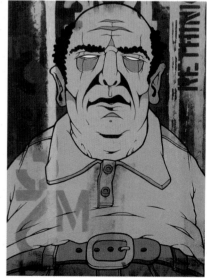

Clockwise from top left: logo; Confront/Deny 01 A; Confront/Deny 01 B; Ritual; Time Capsule; (stencils and acrylic on canvas)

STEFF PLAETZ

Steff Plaetz is a London-based illustrator with a uniquely free line approach to stencilling.

Working with stencils on canvas or on computer, he overlays energetic blocks of colour with sketchily cut lines, creating dynamic figures in motion.

'I really like the aesthetic of stencilling,' Plaetz says. 'A precise but wreckable line.'

Plaetz divides his time between personal and commercial work, with recent solo exhibitions at Arc in Manchester and Bob in New York, and design commissions for Japanese clothing companies Satan Arbeit and Doarat.

Clockwise from top left: Street stencil circa 1997; Premonition Figure 2001 (stencil on canvas); Sports Suite illustration for Adidas/*Sleaze Nation* 1999 (stencil on canvas)

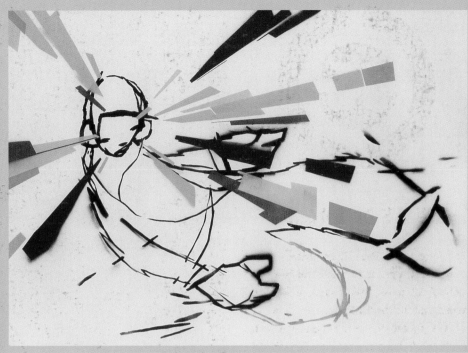

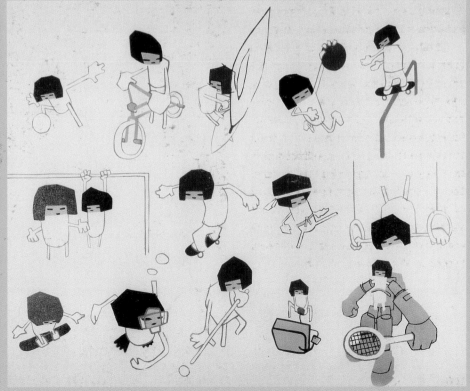

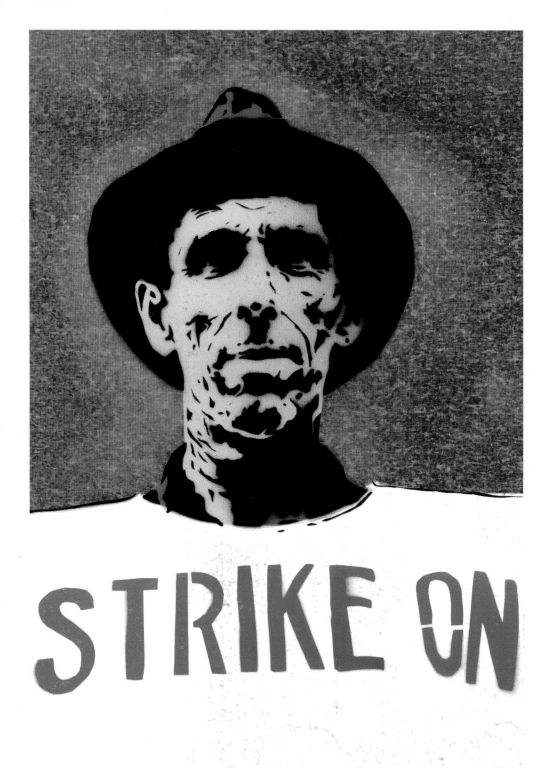

STRIKE ON

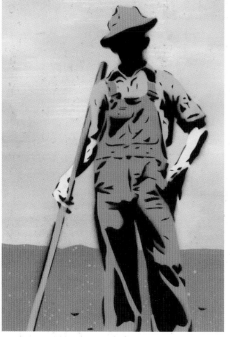

CHRIS STAIN

Baltimore artist and printmaker Chris Stain began to use stencils because he could not afford his own screen-printing equipment.

The switch to stencils worked out well. Stain immediately felt comfortable with spray-paint and was able to work on surfaces such as sheet metal, which are less suited to screen printing. The metal surfaces add another dimension to the picture as Stain leaves areas of copper and steel unpainted.

Stain's images draw on family history and historical documentary.

'It is graffiti but on a different level,' he says. 'I cut stencils as a way of documenting life; as a proof of my own existence and how I deal with that existence.'

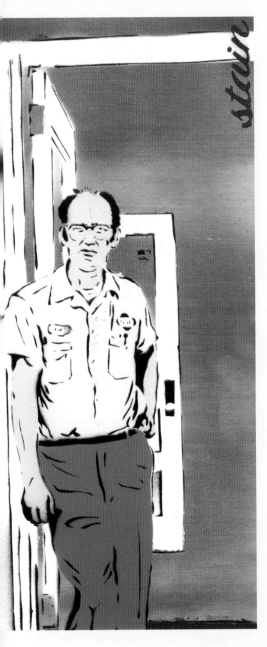

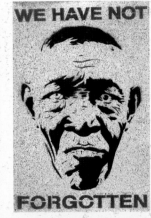

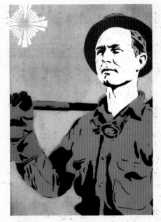

WE HAVE NOT FORGOTTEN

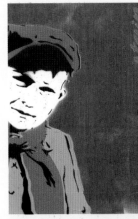

Opposite left: Strike (stencil on steel); Right: From The Good Earth (stencil on board)

This page, clockwise from far left: 8 Lancaster Ave (stencil on copper); Warsaw Ghetto (stencil on steel); William Casby (stencil on steel); Hard Travelling (stencil on copper); In the Dream – Tijuana (stencil on steel)

OUTGOING

FURTHER READING

Cano, Genís, & Anxel Rabuñal, *Barcelona Murs*, Ajuntament de Barcelona, 1991

Chalfant, Henry, & James Prigoff, *Spraycan Art*, Thames & Hudson, 1987

Cooper, Martha, & Henry Chalfant, *Subway Art*, Thames & Hudson, 1984

Huber, Joerg, *Paris Graffiti*, Thames & Hudson, 1986

Kinneir, Jock, *Words and Buildings: The Art and Practice of Public Lettering*, Architectural Press, 1980

Metz Prou, Sybille, & Bernhard van Treek, *Pochoir: Die Kunst des Schablonen-Graffiti*, Schwarzkopf & Schwarzkopf, 2000

Robinson, David, *Soho Walls Beyond Graffiti*, Thames & Hudson, 1990

Left: The Naughties, New York
This page and opposite: Wall, Bristol

WEBSITES

Art Crimes. http://www.graffiti.org/
Jules Backus: www.cooper.edu/art/lubalin/
 ambush.html
Balzi: www.lost.art.br
Bananensprayer: www.bananensprayer.de
Banksy: www.banksy.co.uk
Barcelona: www.bcngraffiti.com
Christopher Bettig: www.455ad.com
Blek le Rat: //bleklerat.free.fr//
Brighton: www.graffiti.org/brighton
Bristol: www.bristol-graffiti.com
CCC Cultural Cryptanalysts Collective:
 www.talkback.lehman.cuny.edu/tb/issue3/
 gallery/ccc.html
Dave & Shep: www.blkmrkt.com

Shepard Fairey: www.obeygiant.com
John Fekner: www.phoenix.liu.edu/~jfekner/
François: www.onthewall.free.fr/index_fr.html
Thierry Geffray: www.sitefun.com/lesmursmurs
Logan Hicks: www.workhorsevisuals.com
Dave Kinsey: www.kinseyvisual.com
Tristan Manco: info@stencilgraffiti.com and
 www.stencilgraffiti.com
Sunil Pawar: www.iamslingshot.com
Steff Plaetz: e-mail steff@f2s.com
Political Graphics: www.politicalgraphics.org
Bernie Reid: www.creativeunion.co.uk
S&H: www.essenhaitch.co.uk
Chris Stain: www.inthedream.com
Swifty: www.swifty.co.uk

Toasters: www.toasterstoasters.co.uk
Urban Artistes: www.ksurf.net/~armvr/index2.
 html
Nick Walker: www.apishangel.co.uk
Dan Witz: www.bway.net/~danwitz/
World Stencils: www.cleansurface.org
Gerardo Yepiz: www.acamonchi.com/gyepiz

ACKNOWLEDGMENTS

Thanks to all the unknown artists.
Thanks to all the artists and photographers who contributed worldwide.
Thanks to everyone who contributed but due to space did not get included.

Artists: Arnaud, Balzi, Banksy, Barney Barnes, Le Bateleur, Thomas Baumgärtel, Chris Bettig, Blek le Rat, Bonehead, Franco Brambilla, Andy Brown, CCC, Chou, Circa, Clone, Dominique Decobecq a.k.a Nice Art, D.T.M. Crew, Fab Four, Shepard Fairey, Pablo Fiasco, Chris Francis, Jaspar Goodhall, Hao, Logan Hicks, David Hopkinson, Bob Kathman, Dave Kinsey, Laszlo, Loony, Laura Mars, Jérôme Mesnager,

Miss-Tic, Misse, Mitch, MurMur, Nano4814, Némo, Nico, Nylon, Orfes, Par 3, Paris, Sunil Pawar, Steff Plaetz, Poch, Poirot, Bernie Reid, Jeff Row, Sniper, Giacomo Spazio, Chris Stain, Alex Stoloff, Andy Stott, STR, Swifty, TNT, Toasters, Seth Tobocman, Tommo, Waek, Nick Walker, Dan Witz, Ian Wright, Xarrs, Gerardo Yepiz, Zao, Zen

Special thanks for their invaluable knowledge, hospitality and contributions to the cause:
UK: Will Barras, Marc Bessant, Stephen Earl, Nylon, Ephrahim Webber
Paris: Blek le Rat, Alexandre Céalis, Thierry Geffray, Sybille Metz Prou, Olivier Schil

Barcelona: Genís Cano, Isabel Chavarria Grau, Francesc Punsola Izard, Jan Spivey
Milan: Franco Brambilla, Giacomo Spazio
USA: Shepard Fairey, Logan Hicks, Dave Kinsey, Dave McElwaine, Mary Peacock, Peter Walsh, Peter Zahorecz

Translations: Simon Sleath

Organizations: PYMCA, Graphotism Magazine, Creative Union

PICTURE CREDITS

Right: Under railway bridge, Bristol